Family Chronicle's
Dating Old Photographs
1840-1929

EDITOR & PUBLISHER
Halvor Moorshead

EDITOR
Jeff Chapman

EDITORIAL ASSISTANTS
Victoria Pratt
Jodi Avery
Rosanne Van Vierzen

SPECIAL PROJECTS MANAGER
Ron Wild

Published by Moorshead Magazines Ltd.
505 Consumers Road, Suite 500, Toronto,
ON, M2J 4V8 Canada
(416) 491-3699 Fax (416) 491-3996
E-Mail: magazine@familychronicle.com

PRESIDENT
Halvor Moorshead

CIRCULATION MANAGER
Rick Cree

SUBSCRIPTION SERVICES
Jeannette Cox
Valerie Carmichael

Family Chronicle is published six times a year
(Jan/Feb, Mar/Apr, May/Jun, Jul/Aug,
Sep/Oct, Nov/Dec).
POSTAL INFORMATION — CANADA
Canadian Publications Mail Product Sales
Agreement No. 1013610. Mailing address for
subscription orders, undeliverable copies and
change of address notice is:
Family Chronicle, 505 Consumers Road, #500,
Toronto, Ontario, M2J 4V8 Canada
POSTAL INFORMATION — UNITED STATES
Periodical Postage Paid Lewiston NY
USPS #015-059,
Postmaster send address corrections to:
Family Chronicle, PO Box 1201,
Lewiston, NY, 14092-9934 USA
US Office of Publication
850 Cayuga St., Lewiston, NY, 14092
© 2000 Moorshead Magazines Ltd. All Rights Reserved.
ISBN 0-9685076-3-8
Subscription Rates to Family Chronicle
Subscription rate for US (US funds):
1 year: $24, 2 years: $40, 3 years: $55

Subscription rate for Canada (Cdn funds):
1 year $28 + GST/HST, 2 years $45 + GST/HST
3 years (18 issues) $59 + GST/HST
Quebec residents add 6.5% QST
GST # 139340186 RT

Toll-Free Subscription Line:
1-888-326-2476

Member of the National Genealogical Society
Printed in Canada

For more information and to place
secure orders visit *Family Chronicle's*
website: *www.familychronicle.com*

One of the most popular features carried by *Family Chronicle* have been our articles on dating old photographs. Although several books have been published on this subject, they all rely mainly on describing what to look for in the picture and show only a handful of examples. These books can be very useful but we have taken a very different approach in that we have printed hundreds of pictures with little comment.

Almost all of us have photographs of unknown subjects and unknown dates. We cannot help you with identifying your subject but this book should help you with establishing the date within a few years. That may, in turn, help with identifying the subject.

We are very grateful to the readers of *Family Chronicle* for their assistance in compiling this book.

Halvor Moorshead
Publisher and Editor
magazine@familychronicle.com

"If you haven't discovered Family Chronicle, you are in for a treat... [it is] beautifully produced and informative."

Myra Vanderpool Gormley, C.G. Los Angeles Times Syndicate

"One of the most informative magazines I have ever seen." — Carole Kiernan, *Family Heirlooms*

"Without a doubt the best journalistically and genealogically printed magazine." — Al and Margaret Spiry, *Madison Courier*

"It belongs on every researcher's bookshelf to be used again and again." — Carlene Marek, *AncestreeSeekers*

"[*Family Chronicle*] has matured into the acknowledged finest genealogical magazine available today."— Bob Meeker, *Legacy of America*

"[*Family Chronicle*] has been one of the brightest new publications, with articles which [are] both easy to read and written by authorities." — Kenneth H. Thomas Jr., *Atlanta Journal Constitution*

For information on bulk sales call **(416) 491-3699**

Family Chronicle
The Magazine for Families Researching their Roots

Use any of these three convenient ways to subscribe:

- Phone Toll-Free **1-888-326-2476**. Please have your Credit Card ready.
- Fax this order form to (416) 491-3996.
- Mail to: *See US and Canadian addresses on page 1.*

Please use this form when ordering at this special rate.

I want to subscribe for:

- ☐ One year (6 issues) at $24 US / $28 Cdn ☐ Two years (12 issues) at $40 US / $45 Cdn
- Payment by: ☐ Check (enclosed) Charge my Credit Card: ☐ Visa ☐ MasterCard
- Canadian orders add 7% GST or 15% HST as applicable. Quebec residents add 6.5% QST.

Card Number_____ Expiry Date_____ /_____

Signature_____

Last Name_____ First Name_____

Address_____

City_____ State/Prov. _____ Zip/ Postal Code _____

Phone Number_____ GST# 139340186 RT **Dating**

Family Chronicle does not rent or sell subscriber names.

Dating 19th-Century Photographs

Andrew J. Morris explains the technicalities and fashion styles of old photographs.

OLD PHOTOGRAPHS have aesthetic and historical value and when they are family photos, there is also nostalgic and sentimental appeal. But sometimes those pictures are not properly identified, which greatly limits their value, both as historical objects and as family mementos. One step that goes a long way towards properly identifying a photograph is to establish the date, at least approximately, when it was taken.

Styles and manufacturing techniques change over time. Automobile enthusiasts can easily tell the difference between a 1955 Chevy and a 1957 Chevy. At the same time, almost all cars from the 1950s have a similar look that lets you place them in that decade, although it may be hard to put those characteristics into words. So too with photographs. With just a little knowledge and experience anyone can learn to determine the date of a photograph within a decade or two, while careful study can allow us to date many images to within a year or two of their creation.

We are going to look at just a few of the characteristics that allow us to determine the date a particular photograph was taken. Many of these characteristics are of the "no earlier than" variety — they were introduced at some known date, but it is impossible to know how long they continued. Styles often came into fashion, grew rapidly to a peak of popularity, then tapered off slowly, so that there are very late examples, though they are much scarcer than those from the peak of popularity.

One complication that arises from the unique character of photography is the distinction between photograph and image. Because we can take pictures of pictures, it is possible to have a brand-new photograph of an image that is a hundred years old. The photographic object before us would then have characteristics found only in modern photographs, while the image would

> ## With just a little knowledge and experience anyone can learn to determine the date of a photograph within a decade or two.

have characteristics of the previous century. Much harder to spot is the reproduction of an 1860s image made in the 1880s. Such copying was not uncommon, and can be found in any large collection of old photos — be aware of that possibility when dating clues seem to conflict.

The Processes

The first clue to the age of a photograph is the type of process used to create it. The earliest photographic images that became available outside the experimenter's laboratory were the Daguerreotype and the Talbotype (later called Calotype). Daguerre introduced his invention to the public in 1839 in France. When Talbot heard of it, he brought forth the invention he had been working on, to vie for the honor of being known as the inventor of photography. The processes were quite different, and produced very different photographic objects. Calotypes were protected by patent and are fairly uncommon, while Daguerreotypes were produced in the millions.

We will mention here only the most popular photographic processes, the Daguerreotype, ambrotype, tintype and paper print. Photographic paper was very thin in the 1800s, so paper prints were pasted to cardboard mounts. While a variety of hard-to-distinguish processes were used to produce paper prints, such as salted paper, albumen, carbon, gelatin and collodian, it is the size of the cardboard mounts that we use to distinguish the most popular types of photographs from the 19th century, the *carte-de-visite* (CDV) and cabinet card.

Daguerreotype 1839-1860

The Daguerreotype uses a polished, silver plated sheet of metal, and once seen is easily recognized by its mirror-like surface. The plate has to be held at the correct angle to the light for the image to be visible. That image is extremely sharp and detailed. The Daguerreotype fell out of favor after 1860 as less expensive techniques supplanted it.

Ambrotype 1854-1860s

The Ambrotype is essentially a glass negative with a black background that makes the image appear positive. It is a cased photo. Invented about 1854, the form lost popularity in the early 1860s when tintypes and card mounted paper prints replaced it.

Tintype 1856-1900

The tintype was introduced in 1856, and enjoyed widespread popularity until about 1900. The tintype gets its name from the fact that the image is produced on a thin metal plate. Like the Daguerreotype and Ambrotype, the emulsion was directly exposed in the camera, without any need for a negative, so the images are often unique. (In later years, cameras with multiple lenses were developed so that as many as a dozen tintypes could be exposed at once.) During the 1860s and 70s small tintypes were often placed

in CDV sized cardboard mounts or paper sleeves.

Carte-de-Visite 1859-1890s

Cartes-de-Visite, or CDVs, are a type of card mounted photograph introduced about 1854 and tremendously popular, especially in America and Europe, from 1860 until almost the turn of the century. The CDV is easily distinguished from other card-mounted

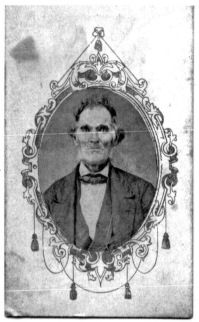

Illustration 1. Picture of William Malster with oval image in ornate frame, ca. 1864. Andrew J. Morris collection.

photos by its size, typically 2.5 x 4 inches (63 x 100 mm) or slightly less. The various characteristics of card mount, image and photographer's imprint often allows these images to be correctly dated to within a few years of their origin.

All of the illustrations accompanying this article are pictures of CDVs.

Cabinet Card 1866-1910

Cabinet Cards, card mounted photographs introduced in 1866, and tremendously popular, especially in the US, from their introduction until just after the turn of the century. The Cabinet Card is easily distinguished from other card-mounted photos by its size, typically 4.25 x 6.5 inches (108 x 164 mm).

Further Clues

Once you have established the type of photograph, there are many more clues that may be used to further narrow the date of creation. Daguerreotypes and Ambrotypes, and sometimes tintypes, are found in cases — either the leather or paper covered wood-frame case, or black molded plastic (yes! this was the first use of plastic) "union" case. Within that

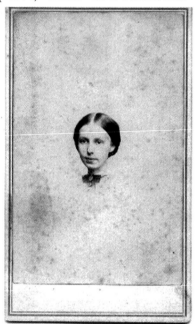

Illustration 2. Picture of Helen E. Tuvill, ca. 1862. Andrew J. Morris collection.

case, the photograph is covered with a brass matte, sometimes encased in a brass "preserver" and placed under glass. If there is no preserver, the Daguerreotype probably dates from the 1840s. If the matte and preserver are both plain, then it dates from 1850-55. If there are incised or pressed patterns and decorations on the matte or preserver, then it was probably produced after 1855.

Tintypes can be the hardest pictures to assign a date to because of their long run of popularity, and the lack of photographer's imprint and other clues. Most tintypes from the 1860s have black backs, while those produced after 1870 are generally brown. Other than that, you mostly have to rely on clothing styles to determine the date.

Card mounted photographs

offer a wide variety of clues about their date. Although we only mention cabinet cards and CDVs here, there were actually over 20 different types of card mounts by the 1880s, differing only in size. From my observations I'd guess 90 to 95 percent of all 19th-century card-mounted photographs were either cabinet card or CDV sized. The earlier mounts were of thinner cardstock, while a thicker paste-

Illustration 3. The backs of four CDVs, showing different imprint styles and a tax stamp.

board was introduced in 1870. This is an early use of true cardboard, it consists of layers of thin paper, with better quality face and back sheets, and three to five layers of cheap inner sheets.

The best way to measure card thickness is with calipers, but obviously not everyone has such a specialized tool handy. Most people do, however, have access to regular 20 pound bond paper, the kind of paper most typically used in copy machines, laser printers, and other computer printers in North America. One sheet of 20-pound bond is about 0.004 inch (0.1 mm) thick. CDV cards six or fewer sheets thick would date from 1858-1869. Cards seven or eight sheets thick date from 1869-1887. Cards nine or more sheets thick date from 1800-1900. Card thickness is less useful for dating cabinet cards.

The color of the card is also a good clue to its approximate age. The earliest cards (1858-1869) were on white cards, though those are often darkened or yellowed with age. White was also commonly used from 1871-74, though on thicker cards. Gray or tan cards were used 1861-66. Gray was also common from 1872-80, though on a thicker card. Yellow was common from 1869-74. A variety of pale colors, lavender, green, blue, etc. were used from 1873-1910. Some of these have one color on front, and another on the back. Chocolate brown or black cards were used from 1877-87.

Card edges were simply cut off square at first (see, for example, illustration 1, 2 or 4). After 1871 the corners were usually rounded (see the bottom two examples in illustration 3). Beveled edges were popular from 1875-1900. Notched edges were common from 1894-1900. Edges were often covered with gilt after 1870.

Many cards have a border of one or two lines, often gilt, around the edge of the front, with the picture pasted inside the border (for example, see illustration 2 or 4). This style was most popular 1861-69, but is sometimes seen later. From 1863-1868 a fancy oval frame, often ornate with tassels and other decorative features was used (illustration 1), with a small picture pasted inside the frame. A similar style is seen in the paper mounts used to display small "gem"-sized tintypes; only the area inside those frames is cut out to allow the tintype to show through from behind. Later cards sometimes had faint geometric patterns printed on the back, mostly 1881-1888.

The photographer's imprint is a wonderful clue to the date of the photograph. Not only can you use external sources like directories and local histories to determine what years that photographer was in business at the location listed, but the imprint itself has stylistic features that changed over the years. As a general rule, simple imprints were used at first, then they gradually became more ornate, until about 1885, when

there was a divergence, with some photographers going back to simpler imprints, while others continued to use more ornate styles.

Imprints on the front of the card are not of much value for dating by stylistic characters, as they are restricted by the space available. On the backs of cards however, the styles changed through the years. If the imprint is small and plain, then a single line imprint usually dates from 1860-62. Two or four lines from 1861-66 (illustration 3, upper left). If these two to four line imprints have the statements "Duplicates can be

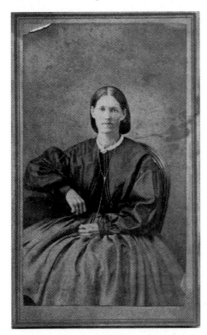

Illustration 4. Picture of "Emily" ca. 1865. Andrew J. Morris collection.

had" or "negatives preserved" they date from 1863 or later. Four or more lines with larger type characters and often additional information date from 1863-67. Imprints with curved lines of text with curved lines and curlicues between and around them date from 1863-65. After 1867 most imprints became larger. Those printed lengthwise (parallel to the long edge of the card) (illustration 3, lower right) usually date 1868-82. Imprints with fancier type fonts, often with a different font for each line and sometimes a few curlicues in between, date from 1870 and later.

From 1862-1865 it was popular

to have a frame or cartouche around the imprint (illustration 3, upper right), with various geometric patterns and lines. A logo above the imprint, such as an eagle, artist's palette, Liberty, etc., was used 1862-1866. The cherub and camera logo was in style from 1865-1872. The logo of a photographic association, the NPA, was used from 1871-1874 (illustration 3, lower left).

After 1872 the photographer's imprint was often a large, elaborate design that covered most of the back of the card. Those using an Egyptian or oriental motif usu-

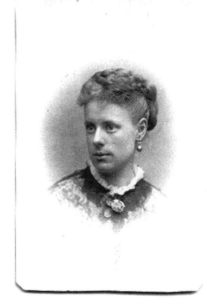

Illustration 5. Picture of "Susie, June 1874." Andrew J. Morris collection.

ally date 1881-1886.

The presence of a tax stamp on the back of a photograph indicates that it was taken during the Civil War by a photographer on the Union side, and dates between 1 August 1864 and 1 August 1866 (illustration 3, upper right). If it is a one-cent stamp, it was taken after 1 March 1865.

The image itself may also hold clues as to the date a photograph was taken. If the image is of the head only, or head and shoulders, the size of the head can be an indication of the date. If the head is 3/4 inch wide, or less, it usually dates from 1860-1864 (illustration 2). If it is about one inch wide,

then it likely dated 1860-1867. If it is 1.25 to 1.75 inches, then it dates 1866-1875 (illustration 5). A large head, two inches or more in width, dates from 1874 or later.

Clothing styles, of course, were very sensitive to stylistic changes — especially women's dresses. Photographs in the 19th century were not the impromptu snapshots of today, but formal occasions that required one's best dress. Hairstyles, jewelry, parasols and other fashion paraphernalia all changed from year to year. There are far too many such characteristics to cover here, but I'll mention a few of the most obvious. Women in the 1840s wore high, tight corsets that gave their upper torso a V shape. Dress sleeves were tight around the arm. In the early 1850s many women wore their hair in a style that presents a distinctive silhouette in photographs, with broad loops just over the tops of the ears. Later in the decade the loops became

softer and lower, often covering the entire ear, but not extending out so far as they had earlier. Men's neckties in the 1850-1857 period, were stiff, horizontally tied, two-inch wide silk black or checked cloth that extended out on one side, giving an asymmetric appearance. Women's dresses of the 1860s had wide and billowing sleeves in bell-shaped flares (illustration 4), or more modestly flaring bishop's sleeves. In the 1870s and 1880s dresses lost the round profile characteristic of hooped skirts, and became narrow when viewed from the front, but often had a bustle or bulge at the back. In the early 1890s dresses had a small vertical puff at the shoulder, which over the next few years expanded into the full "leg-o-mutton" sleeve, reaching its greatest size in 1897, then contracting somewhat again so that in 1898 a round puff covered the upper arm and shoulder.

Use the changing character of

photographic styles and techniques to establish an approximate age for your old photographs, and internal clues of clothing styles to refine that date, and you will soon learn to identify the time period for old photographs at a glance. Not only will your treasured heirlooms have greater historic value, but you will learn to better appreciate your ancestors' lifestyles.

Further Reading

Dating 19th-Century Photographs www.genealogy.org/~ajmorris/

Dressed for the Photographer by Joan Severa (Kent State U., Kent, OH 1995).

Collection, Use, and Care of Historical Photographs by Robert A. Weinstein and Larry Booth (AASLH: Nashville, TN 1977) .

Cartes de Visite in 19th Century Photography by William C. Darrah (Darrah: Gettysburg PA 1981).

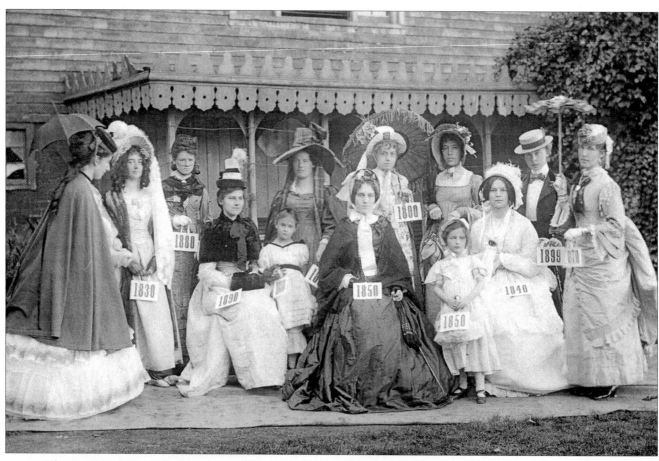

A fascinating photograph taken by E. Whitman in Rye, Sussex, Britain in 1899. The photograph was supplied by Nora Hockin who has ancestors among the subjects. The lady on the left represents 1860, the young girl (fifth from left) 1830, the lady behind her 1810 or 1820, while 1870 is represented by the lady on the extreme right.

Dating Old Photos

What to look for when dating your photographs.

Dating from Photograph Type

Although the technical production of a photograph may be useful when trying to establish a date, it can be misleading. Photographs were being copied, usually using the latest process, from the very early days of photography. It is probably fair to say that a photograph may originate earlier than the process used to reproduce it but not later.

Dating Clues

Clothing fashions changed just as rapidly 100 years ago as they do today: anyone who has studied newspapers from the last century will have seen that even stores in small towns advertise the "latest fashions" from New York, London and Paris. Many people seem to believe that fashions in isolated communities could be years behind those in major cities but this does not appear to be important. The differences between fashions in Europe and North America are also small; without reading the full details, we have not been able to tell the country of origin by looking at the fashions. This does not apply of course when the subjects are wearing "national costumes" which they often did in formal portraits.

Changes in women's clothing fashions are more noticeable than those for men. Possibly this results from most women's reluctance to be photographed unless they are well turned about with their hair adjusted while men are usually happy to be photographed

> **B**ROWN AHEAD.
>
> If you want a small Ambrotype or Photograph, go to BROWN'S.
> If you want a Crystalotype, go to BROWN'S.
> If you wish your likeness in a locket, go to BROWN'S.
> If you would get an Ambrotype, any size, go to BROWN'S.
> If you want a small sized Photograph, go to BROWN'S
> If you want a Photograph, life size, go to BROWN'S.
> If you want a Photograph, in India ink, or colored in Oil, or with Water Colors, go to BROWN'S.
> If you want any old Daguerreotypes or Ambrotypes copied, same size or enlarged to Photographs, be sure and go to BROWN'S.
> A new lot of Cases and Frames just received from New York, and cheap. Call and see for yourselves, at 101 Westminster st, opposite the Arcade. s28

Photographer's advertisement from the **Providence Evening Press,** *3 October, 1860. Note the copying service offered.*

casually, unshaven and in working clothes.

Hair

Hairstyles of both sexes, but especially for women, changed many times during the period that we are covering and are as distinctive as clothing fashions. In all the earlier photographs, all women parted their hair in the middle and not until the mid-1870s do other hairstyles become apparent. The rule was apparently so inflexible that this is one way to tell if the child wearing a dress is male or female (many young boys wore dresses in their early years): the boys' hair is parted on one side.

Facial hair on men was also subject to fashion.

Poses

Although we do show a few pictures of groups from the early years, people were more usually photographed individually. You may also notice that in the pictures we have included here, we have to get to 1901 before we see someone smiling. Many of the subjects look positively unhappy but I suspect this was an attempt at looking dignified!

It is surprising to many of us that men seem somewhat ungallant by being seated while their women-folk stand and this certainly continued until the 1910s.

Photos Used

We have tried to select the photographs for their potential to help others. The quality of the picture was regarded as secondary to the clues that it may contain. Many of the photographs have been enhanced by correcting the contrast range. This is easily done with a scanned image and can result in a dramatic improvement.

Although we have included a high proportion of the photographs submitted to Family Chronicle over a two-year period, we rejected several, as we believe the dates were wrong. If we had any doubt, we left the picture out. We suspect others referred to the date of birth of the subject, not the date of the photograph. We hope we have caught all these.

Several photographs from the 1840s and 1850s are from the Library of Congress collections. These are credited as (LoC).

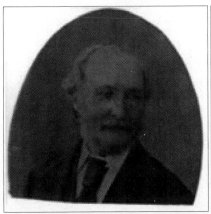 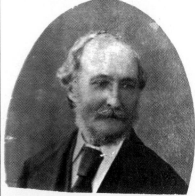

The most common problem with old photogaphs is poor contrast range: sometimes the image is virtually black or the image is badly washed out. The original image is shown left. The picture on the right has only had the contrast and brightness ranges corrected.

Sam Houston, between 1848 and 1850.
Mathew Brady Studios. (LoC)

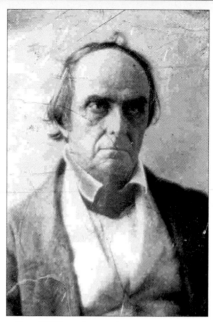

Daniel Webster, Senator from Massachusetts,
between 1845 and 1849.
Mathew Brady Studios. (LoC)

Dolley Madison, 1848.
Mathew Brady Studios. (LoC)

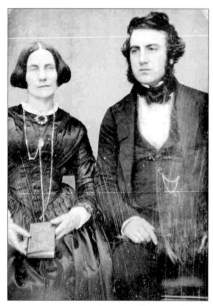

David and Ellen Bell, between 1840 and 1850.
(LoC)

Henry, George and Stephen Childs, 1842.
Photographer John Plumbe. (LoC)

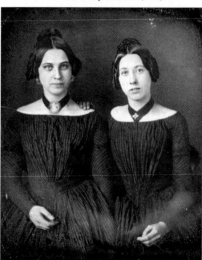

Tirzah Baker (Russel) and Catherine Baker
(Mayo), 1846-48. (Sandra Gilley)

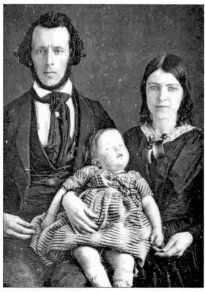

The Adams family, 1846. (LoC)

James Duncan, between 1844 and 1849.
Mathew Brady Studios. (LoC)

Winfield Scott, 1849.
Mathew Brady Studios. (LoC)

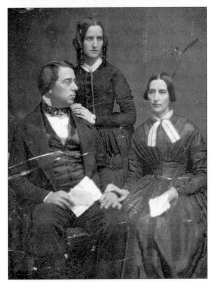

The George Perkins Marsh family, between 1844 and 1849. Mathew Brady Studios. (LoC)

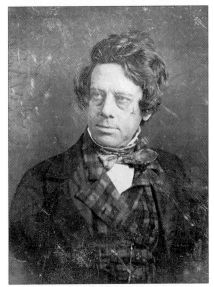

Henry Inman, between 1844 and 1846. Mathew Brady Studios. (LoC)

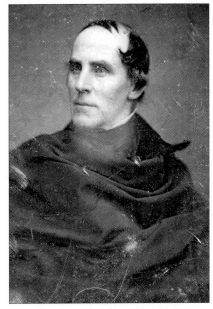

Thomas Cole, between 1844 and 1848. Mathew Brady Studios. (LoC)

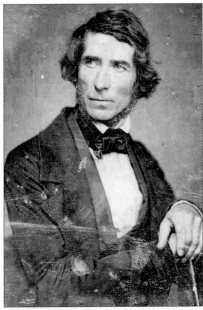

Asher Brown Durand, between 1845 and 1850. Mathew Brady Studios. (LoC)

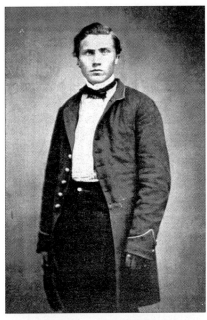

Willie Weller, 1845. (Sara Robertson)

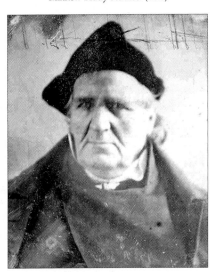

Philander Chase, between 1844 and 1852. Mathew Brady Studios. (LoC)

Lyman Beecher, between 1845 and 1850. Mathew Brady Studios. (LoC)

Alexander Barrow, between 1844 and 1846. Mathew Brady Studios. (LoC)

Zachary Taylor, between 1844 and 1849. Mathew Brady Studios. (LoC)

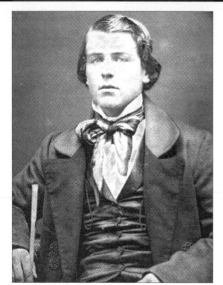

Joseph Hockin, c. 1850.
(Nora Hockin)

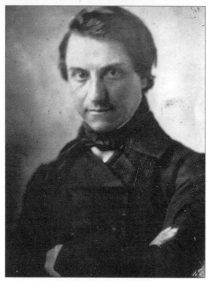

Charles Bradhurst, 1850.
Photographer Rufus Anson. (LoC)

Charles (Carolus) Laurier, 1850.
(Joseph LaMarche)

Katherine Kittel and John G. Fischer, 1859.
(Ann Derner)

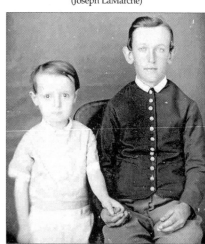

Unidentified subjects, c. 1850.
(LoC)

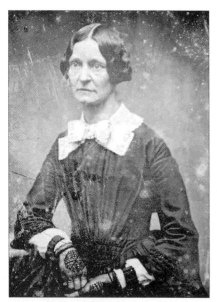

Unidentified subject, c. 1850.
(LoC)

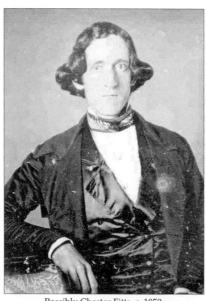

Possibly Chester Fitts, c. 1850.
(LoC)

Alexander Bell (grandfather of Alexander Graham Bell), c. 1850. (LoC)

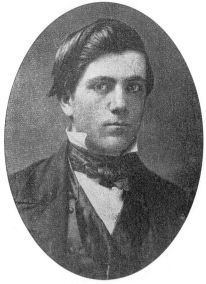

Peter Jackson Pefley, 1852. (Virginia Bradford)

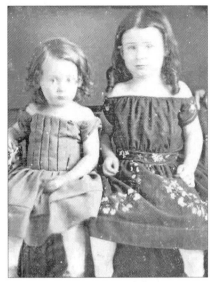

Unidentified subjects, c. 1850. (LoC)

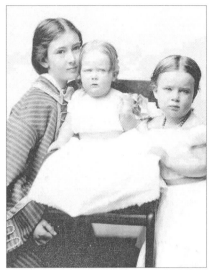

Gertrude Mercer Hubbard Grossman, Mabel Hubbard Bell and Grace Hubbard Bell, c. 1850. Photograph attributed to Southwork & Hawes. (LoC)

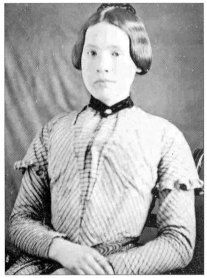

Unidentified subject, c. 1850. (LoC)

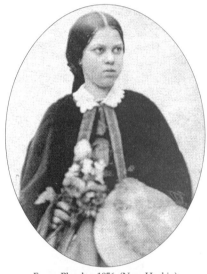

Fanny Plomley, 1856. (Nora Hockin)

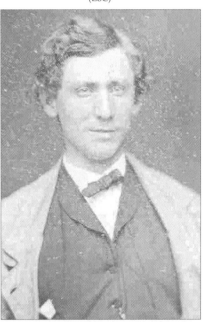

Charles Bradhurst, c. 1850. Photographer Rufus Anson. (LoC)

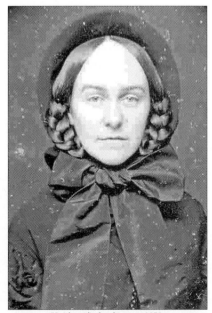

Unidentified subject, c. 1850. Photographer Rufus Anson. (LoC)

Unidentified subject, c. 1850. Photographer Angus Washington. (LoC)

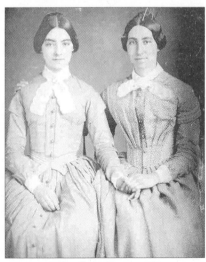

Unidentified subjects, c. 1850. Photographer Harvey Marks. (LoC)

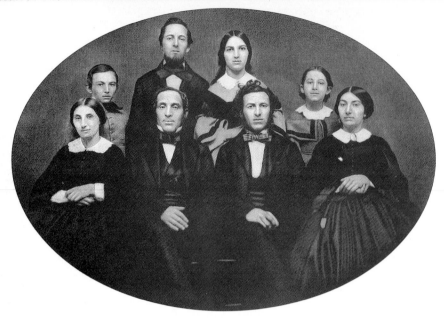

The Horace Putnam family, 1858.
(Clara Obern)

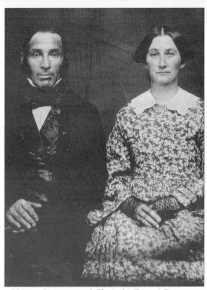

Horace Putnam and Clarinda (Boyce) Putnam,
c. 1855. (Clara Obern)

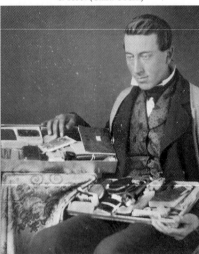

Unknown salesman with his products, c. 1850.
(LoC)

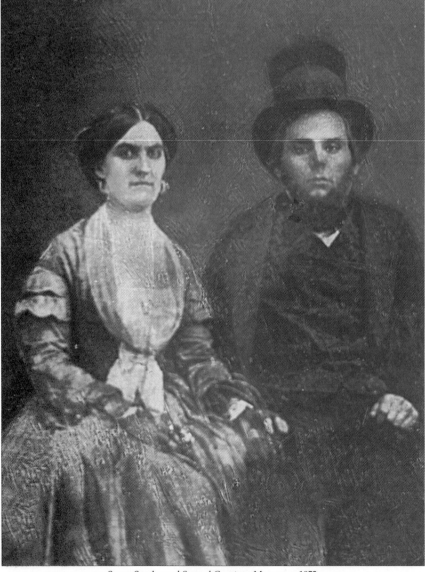

Susan Snyder and Samuel Courtney Morgan, c. 1852.
(Halvor Moorshead)

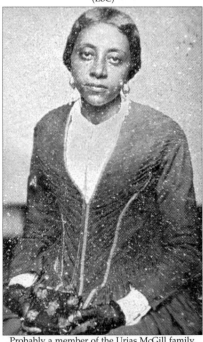

Probably a member of the Urias McGill family.
Photographer Augustus Washington, c. 1850.
(LoC)

Rachel Pease Stone, c. 1850.
(Nan McComber)

Mrs. Plomley, 1854.
(Nora Hockin)

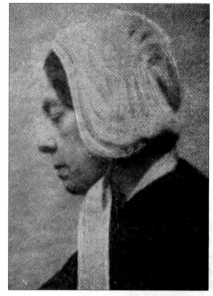

Mary Anne (née Amon) Vidler, 1854.
(Nora Hockin)

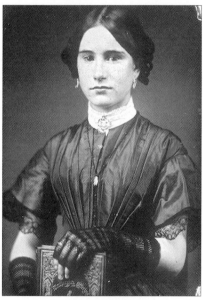

Unidentified subject, probably 1851. (LoC)

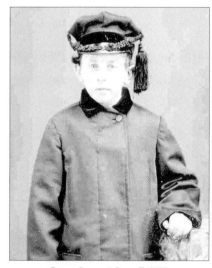

George Leverett Stowell, 1855.
Photographer Abraham Bogardus. (LoC)

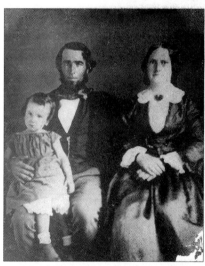

Gerald and Elizabeth Eversden Howatt and their
son, David, 1855. (Bill Savage)

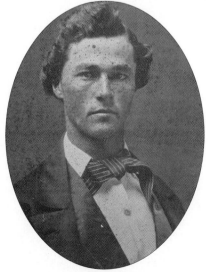

Reuben Michael Gonder, 1859.
(David Mildon)

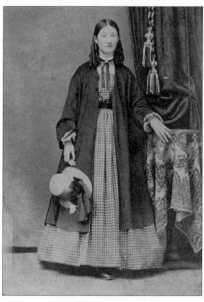

Margaret Haughey, 1857.
(Richard A. Haughey)

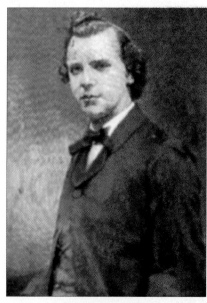

Unidentified subject, 1851.

Jane and Joseph Hockin, 1860.
(Nora Hockin)

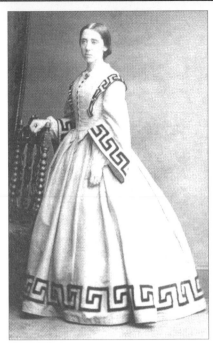

Albinia (Collyer) Vidler, 1860.
(Nora Hockin)

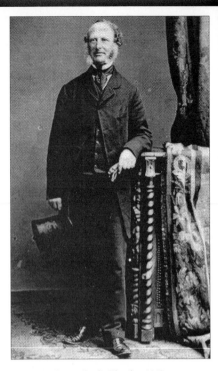

James Foulis Plomley, 1860.
(Nora Hockin)

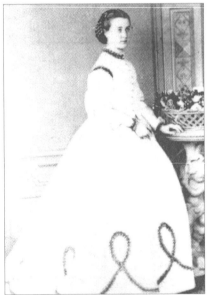

Anna Selmes Collyer, 1864. (Nora Hockin)

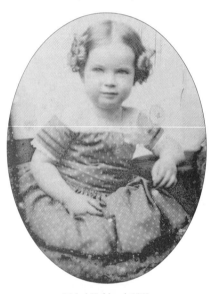

Mabel Hubbard, 1860.
(LoC)

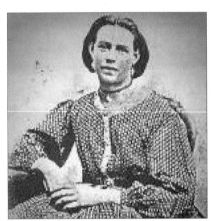

Unidentified subject, 1862.
(James Booker Manwill)

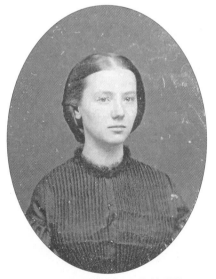

Augusta Currie Bradhurst Field, 1862.
Photographer Rufus Anson. (LoC)

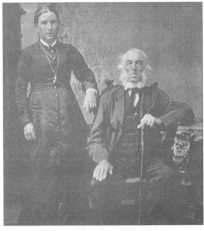

John Gordon Campbell and Jean McMichael
Campbell, 1862. (Darlene Conley Dean)

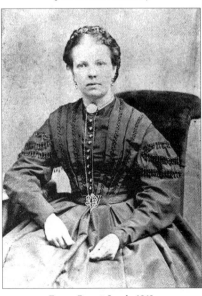

Emma Bassett Leech, 1860.
(Louise Rustad)

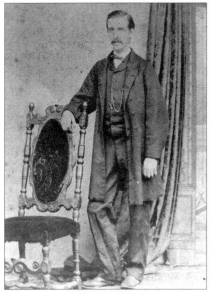

Sibbs Leech, 1860.
(Louise Rustad)

William and Mary Pederick, 1860.
(Ross Pederick)

Sibbs Richard Leech, 1860.
(Louise Rustad)

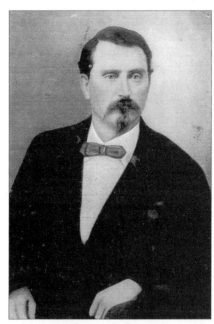

William Riley Stephens, 1860.
(Mary Nell Burnett)

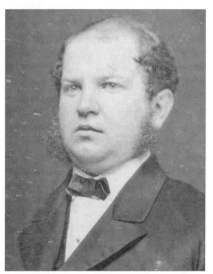

H. H. Fage, 1862.
Photographer Rufus Anson. (LoC)

John Malcolm Campbell and William Hunter
Campbell, 1862. (Darlene Conley Dean)

William Henry Harrison Wooster (wearing Civil
War uniform), c. 1861. (Clara Obern)

Frederich Kohlhagge, between 1861-1869.
(Clara W. Thompson)

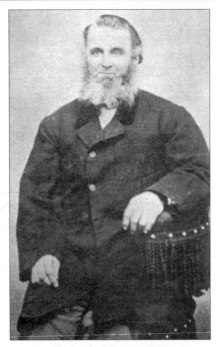

Phineas Cook Stone, c. 1862.
(Nan McComber)

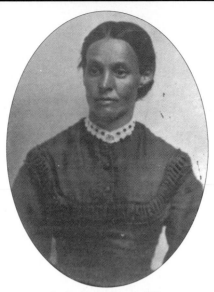

Louisa (Bixler) Stoner, 1862.
(Mary Nell Burnett)

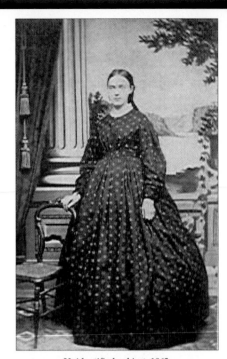

Unidentified subject, 1862.
(Marguerite Main)

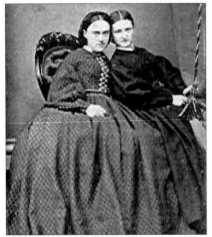

Unidentified subjects, 1862.
(Marguerite Main)

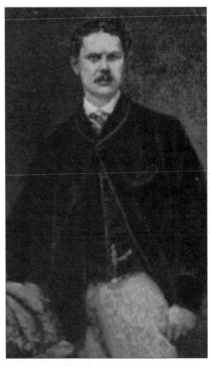

Unidentified subject, 1861.

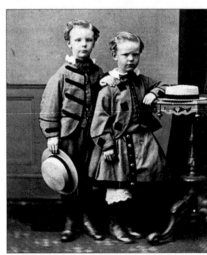

Hedley Goodall Saville and William Henry
Saville, 1863. (Elizabeth Saville)

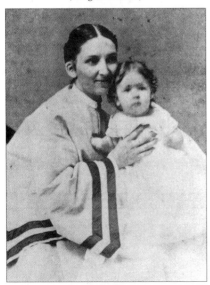

Unidentified subjects, 1864.
(Clara Obern)

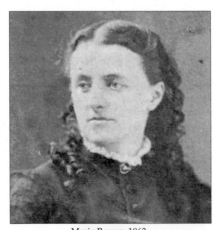

Maria Bowes, 1863.
(Liz Schmidt)

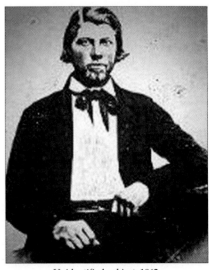

Unidentified subject, 1862.
(Sarah McClellan Marwill)

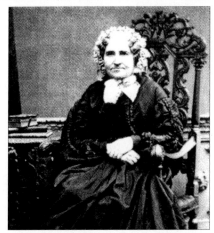
Elizabeth (Selmes) Collyer, 1864.
(Nora Hockin)

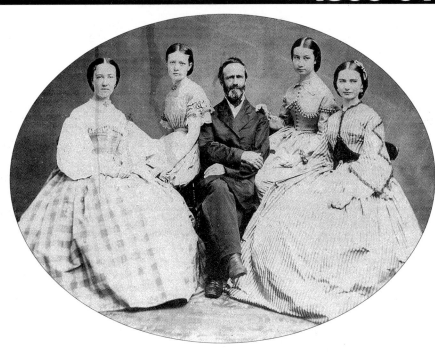
Bowton College Commencement: Caroline Swift, Margaret Merrill, Charles Stackpole, Kate Beaumont and Sophia Dow, 1864. (Nora Swift Egliht)

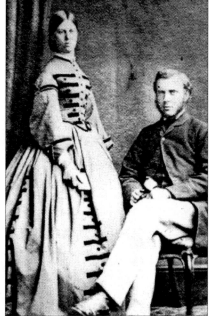
Fanny (Plomley) Collyer and John Collyer, 1864.
(Nora Hockin)

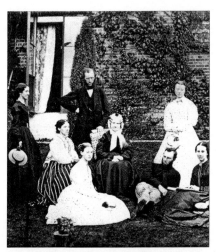
The Collyer family, 1864.
(Nora Hockin)

Isabel Carmichael and James Crerar, 1864.
(Shirley Ramsay)

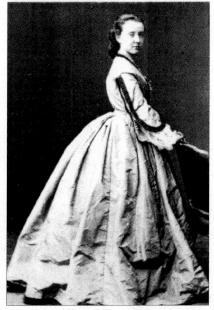
Fanny Collyer, 1864.
(Nora Hockin)

James Bemis Maxham, 1864.
(Jack Maxim)

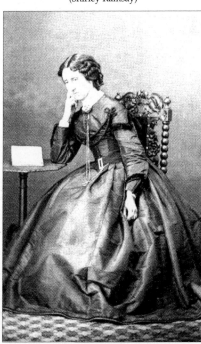
Sarah Elizabeth Collyer, 1864.
(Nora Hockin)

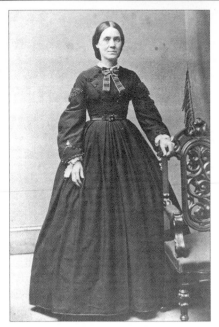

Sarah (Carpenter) Dickinson, 1865.
(Kenneth L. Dyer)

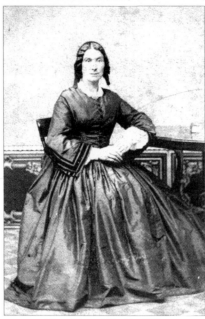

Mary (Martyn) Hockin, 1865.
(Nora Hockin)

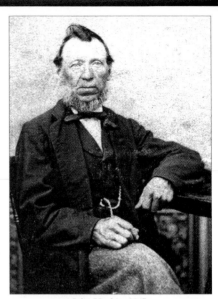

John Hockin, 1865.
(Nora Hockin)

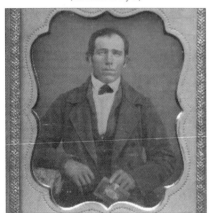

Rev. John Garman, 1865.
(Nancy H. Stock)

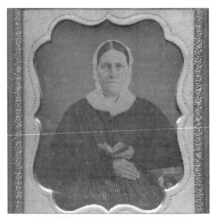

Magdalina Stockey Garman, 1865.
(Nancy H. Stock)

Unidentified subjects, 1865. (Terence Allen)

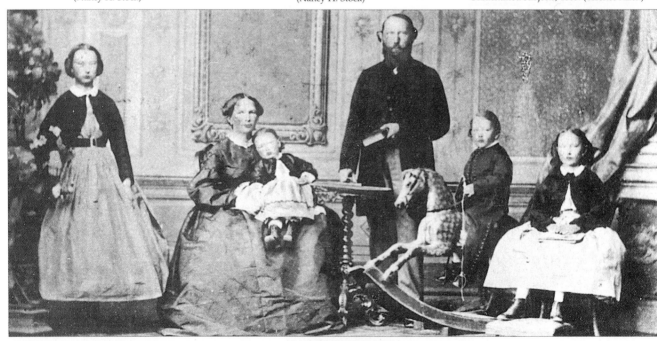

The Kraisse family, 1865.
(Tanya G. Kloesel)

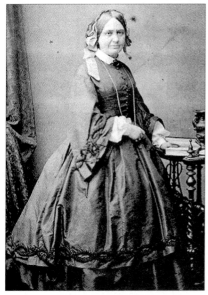

Unidentified subject, 1865.
(Terence Allen)

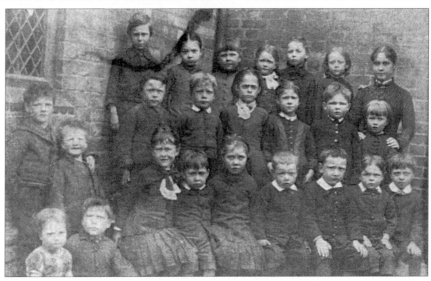

Class picture with Henry and George Harwood, 1865-67.
(Phyllis Libby Glynn)

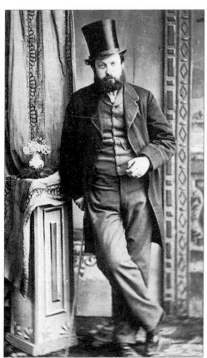

Unidentified subject, 1865.
(Terence Allen)

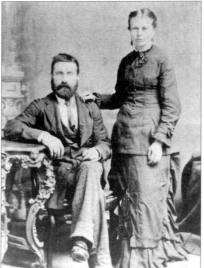

Tom and Mary (Bassett) Liddle, 1866.
(Louise Rustad)

Unidentified subject, c. 1865.
(Clara Obern)

Unidentified subject, 1865.

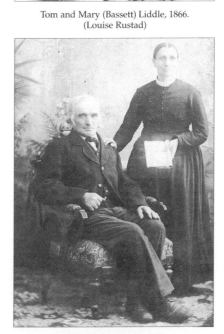

Unidentified subjects, 1867.
(Richard Balge)

Thomas Jefferson Beard and Cyrus Beard, 1865.
(Virginia Bradford)

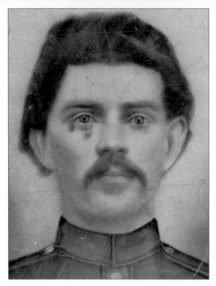

Layfayette A. McNabb, 3rd Kentucky Mounted
Infantry, C.S.A., 1868. (Bruce Burkeen)

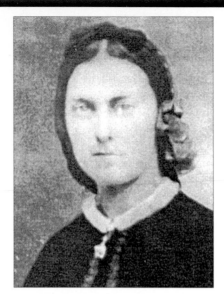

Mary Elizabeth (Kromer) Bush, 1867.
(Roy Clement)

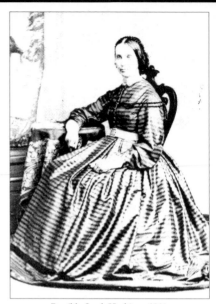

Possibly Sarah Hockin, c. 1866.
(Nora Hockin)

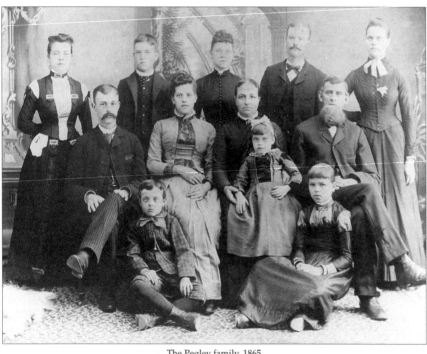

The Pegley family, 1865.
(Barbara L. Volpe)

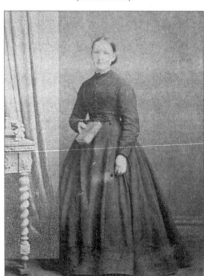

Elizabeth Brewer, 1868.
(Phyllis Libby Glynn)

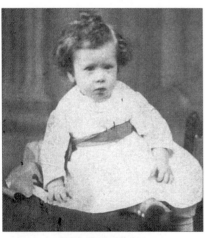

George H. Merrill, 1869.
(Clara Obern)

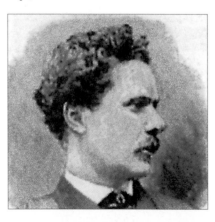

Unidentified subject, 1866.

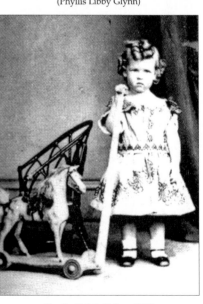

Charles Ralph Collyer, 1868.
(Nora Hockin)

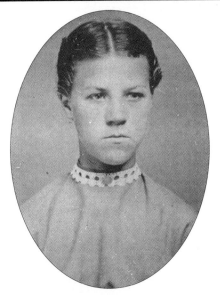

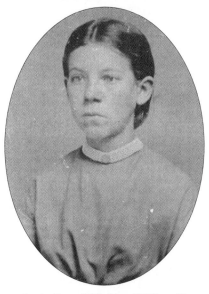

Mary "Mollie" Stoner, 1872. (Mary Nell Burnett)

Louisa Stoner, 1872. (Mary Nell Burnett)

Mary Anna Fette and John Bernzen, 1870.
(Raymond W. Bealman)

Thomas H. Simmons and Isabelle Clara Truran, 1874. (Diane Hall)

James Smith Burcham, 1870.
(Carolyn Spence)

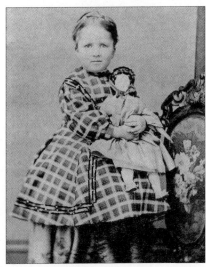

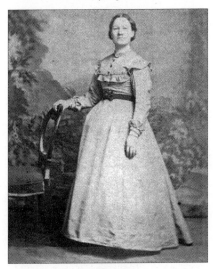

Clara L. Wooster, 1870.
(Clara Obern)

Ira Hall, 1870.
(Kelly Hokkanen)

Annie Brewer, 1871.
(Phyllis Libby Glynn)

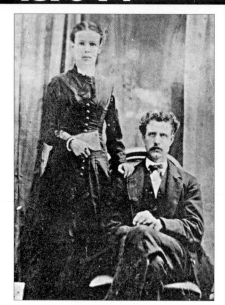

Wedding day photograph, 1872.
(Jane Hopkinson)

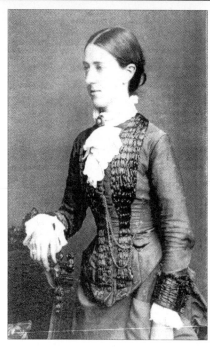

Anna Selmes Collyer, c. 1870.
(Nora Hockin)

Unidentified subjects, 1870.
(Terence Allen)

Unidentified subject, 1873. (Phyllis Libby Glynn)

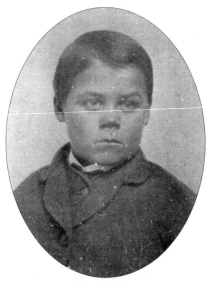

John Stoner, 1872.
(Mary Nell Burnett)

Albert Bierstadt, 1870.
(LoC)

Frank Stoner, 1872.
(Mary Nell Burnett)

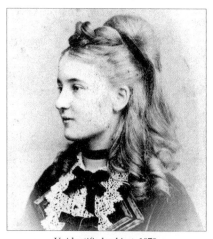

Unidentified subject, 1870.
(Terence Allen)

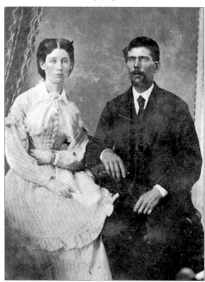

Cynthia and Ira Cutler Garman, 1871.
(Nancy H. Stock)

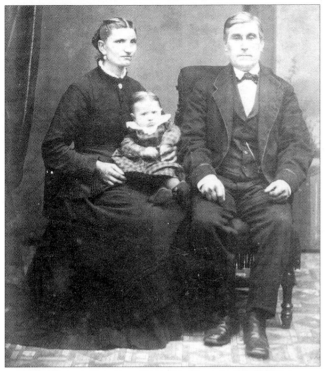

Louis Ludwig Kropelin and Frederioka Hagele Ludwig (holding) Christian Charles, 1870. (H. Jack Wells)

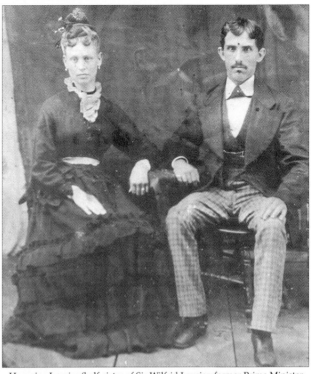

Honorine Laurier (half-sister of Sir Wilfrid Laurier, former Prime Minister of Canada) and Moise Lamarche, 1874. (Joseph H. LaMarche)

Thomas Moorshead, between 1872 and 1879. (Halvor Moorshead)

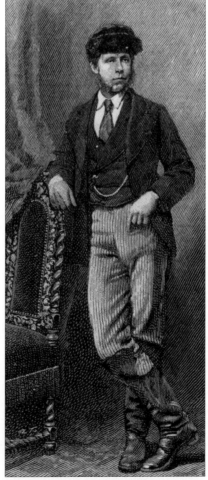

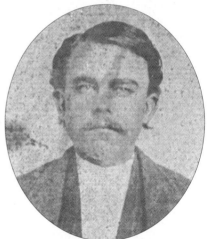

Swan Mongus Anderson, 1872. (Kathleen K. Graham)

Unidentified subject, 1872.

F. C. Selous, 1870. From a photograph by Mondel and Jacob, Wiesbaden. (Strand)

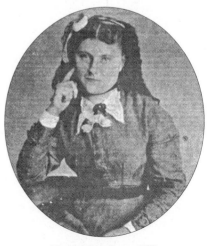

Elizabeth Jane Regan, 1872. (Kathleen K. Graham)

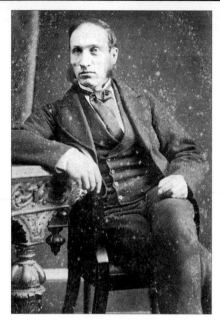

Unidentified subject, 1870.
(Terence Allen)

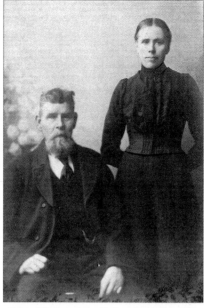

Robert Nicolson and wife, Janet Jamieson, 1873.
(Valerie Josephson)

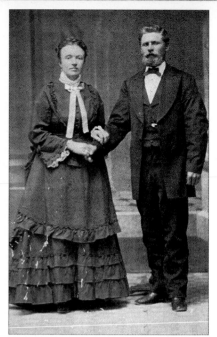

Anton Franz Haverkamp and Maria Louisa
Schulte, 1873. (Raymond W. Baalman)

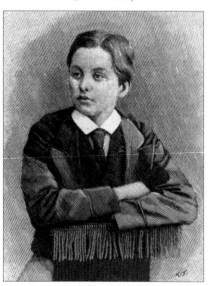

George Curzon, c. 1870. From a photograph by
Hills and Saunders, Eton. (Strand)

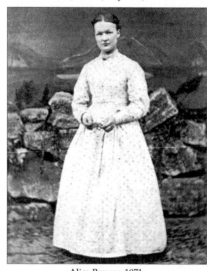

Alica Brewer, 1871.
(Phyllis Libby Glynn)

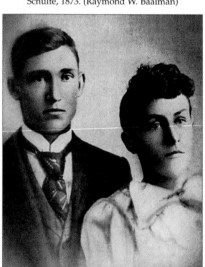

Jim and Essie Lawson, 1874.
(Jim Lawson)

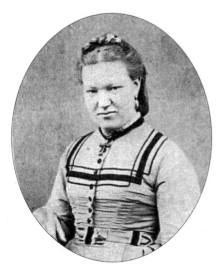

Sarah Brewer, 1872.
(Phyllis Libby Glynn)

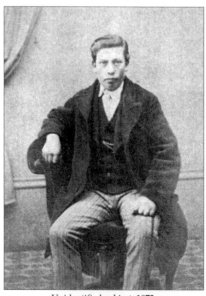

Unidentified subject, 1872.
(Phyllis Libby Glynn)

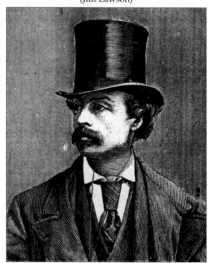

William Quiller Orchardson, 1870. From a
photograph by Hills and Saunders, Oxford.
(Strand)

Luella Emma Biedermann, 1877.
(Leona Carder)

Unidentified subject, 1875.

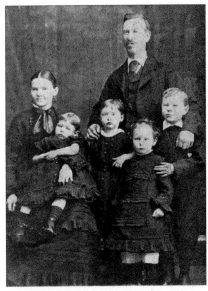

Robert Henry and Margaret Thomlinson with
John, Robert (still in skirts) Hannah and Mary,
c. 1877. (Mary M. Holland)

Unidentified soldier, 1875.
(Sandra Kampf)

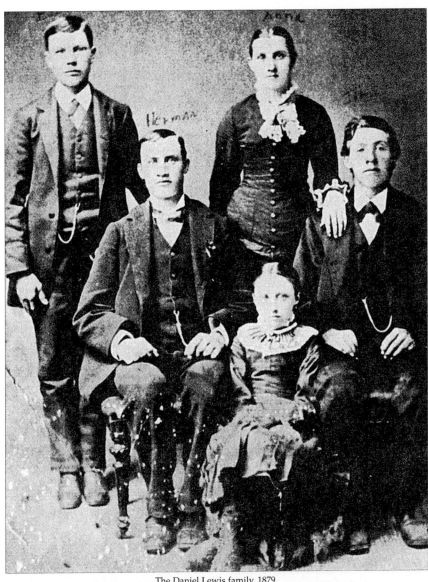

The Daniel Lewis family, 1879.
(Linda Evans)

Loretta May Gilbert Williams, 1875.
(Karen L. Chabot)

Mary Elizabeth, Thomas Henry and Mary Ann
Butler, c. 1878. (Nan McComber)

Isaiah Ragan and family, 1877. (Michael W. Ragan)

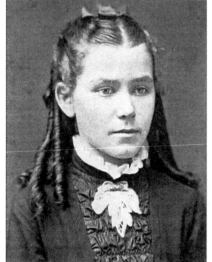

Ida Luella Sandford, 1879. (Kathleen K. Graham)

Elizabeth Pemberton with children Thomas and
John, 1879. (F. Nelson)

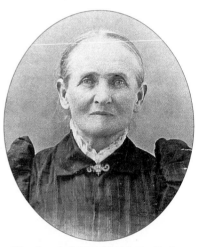

Ellen Campbell, 1876. (Virginia Bradford)

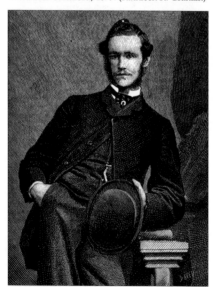

George Wyndham Kennion, 1879.
From photograph by Hills and Saunders, Oxford.
(Strand)

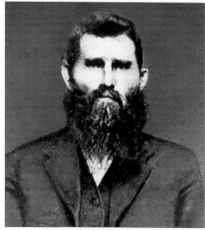

Unidentified subject, c. 1875-1880.
(Martha Smith)

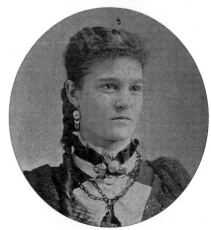

Unidentified subject, 1876.
(Virginia Bradford)

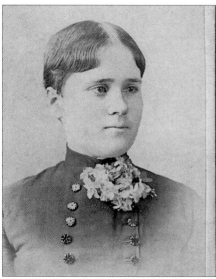
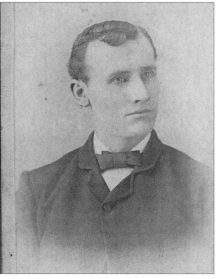

College students, 1881. (Richard A. Haughey)

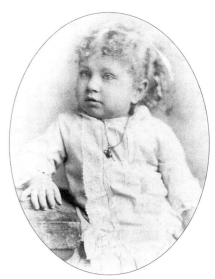

Edith Woolley, 1881. (Virginia Bradford)

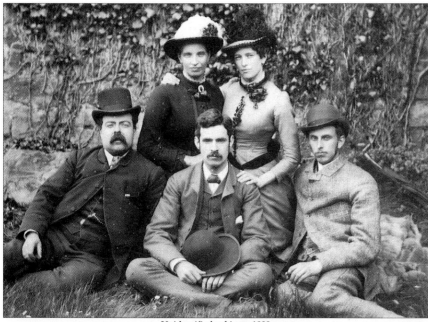

Unidentified subjects, 1880.

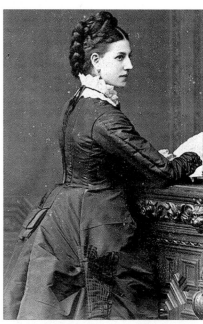

Unidentified subject, 1880.

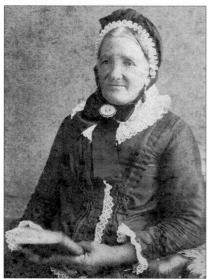

Sophia Spiller Smith Sutton, c. 1882.
(Sandra J. Coulter)

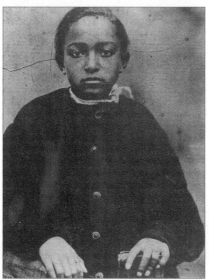

Celia Buauford, 1882.
(Elizabeth J. Hughes)

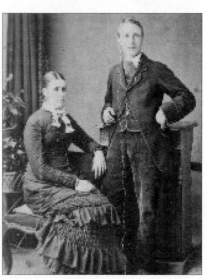

Ellen (née Smyth) and James Wiggins, 1883.
(Roger Clarke)

Mary Elizabeth (née Burden) and Michael Hickey, 1880. (Mary M. Holland)

John (Jack) Robert Harris, 1880.
(Tanya G. Kloesel)

John Andrew Haughey (holding horse
"Whitefoot"), 1883. (Richard A. Haughey)

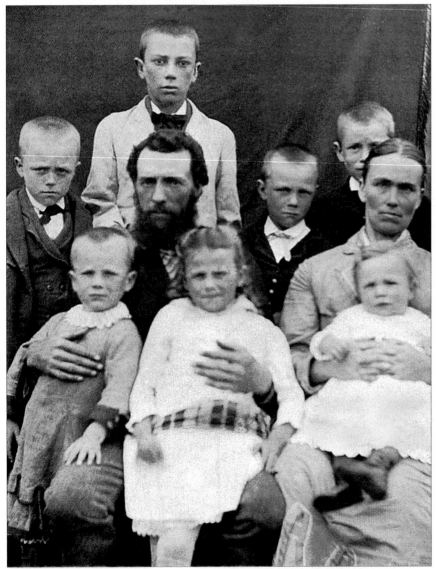

William Henry Marshall and family, 1881.
(Elaine Macey)

Mary Magdalene Sophia Lausen Harris, 1880.
(Tanya G. Kloesel)

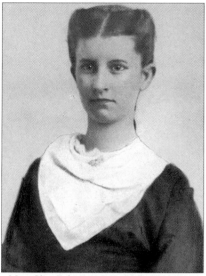

Mary Olive Robinson, 1883. (Kelly Hokkanen)

Unidentified subjects, 1883. (Avanelle Cook)

Alton Clark, c. 1880. (Eugene Clark)

Mariah Peasley, 1881. (Sara Robertson)

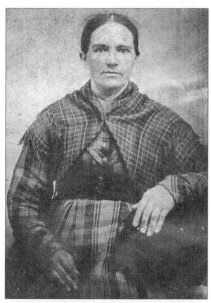

Hester Deacon, 1880. (Kevin Nickel)

Paul Berryman, 1880. (Elizabeth J. Hughes)

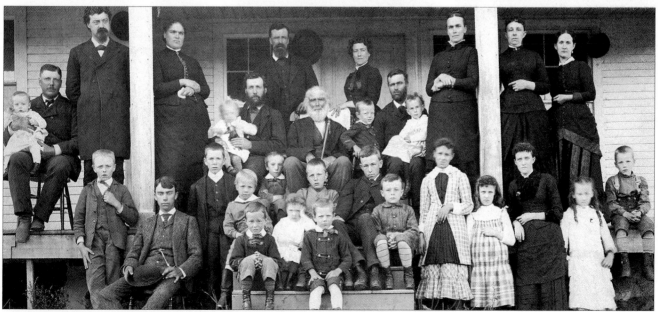

The Marshall and West families, 1884. (Elaine Macey)

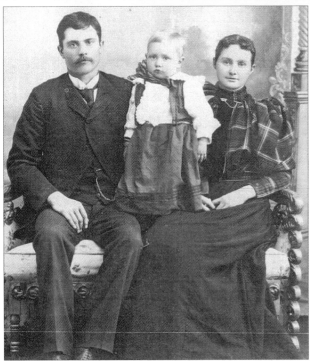

Jacob Hendrickson Potts, George Leander Potts and Nancy Catherine Agnew Potts, 1883. (Karen L. Chabot)

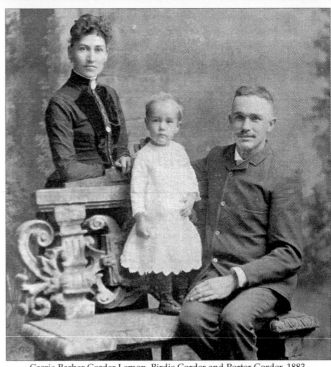

Carrie Barber Corder Lemon, Birdie Corder and Porter Corder, 1883. (Sara Robertson)

Unidentified subject, 1880.

George Guy Harwood, c. 1881. (Phyllis Libby Glynn)

Samuel Teal Berryman, 1880. (Elizabeth J. Hughes)

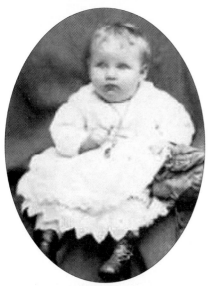

Clara Belle Simmons, 1881. (Diane Hall)

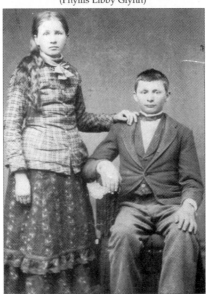

Unidentified subjects, 1880. (Avanelle Cook)

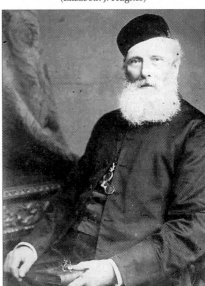

Rev. Gilbert William Robinson, 1880. (Mary M. Holland)

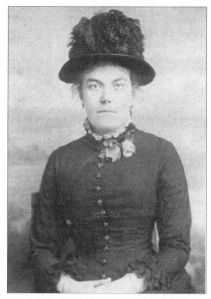

Minnie Caroline Susan Cheese, c. 1886.
(Nan McComber)

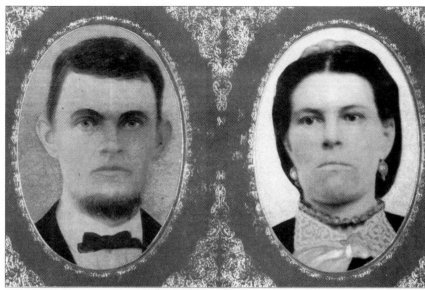

William and Lucretia Brown, c. 1885.
(Nan McComber)

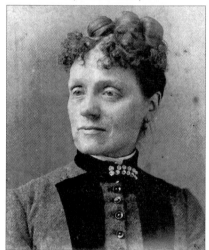

Jenny Selina Howatt, 1885. (Bill Savage)

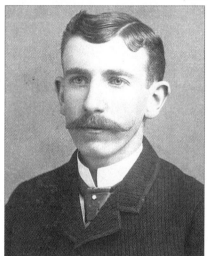

Thomas K. Adlard, 1889. (Virginia Bradford)

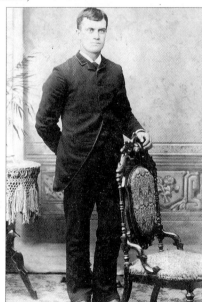

Frank Henry Matteson, 1886. (Karen Ellsworth)

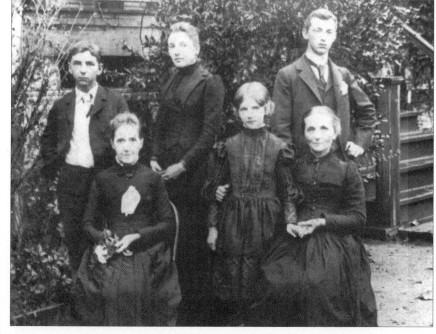

The Carson family, 1889. (Kay White)

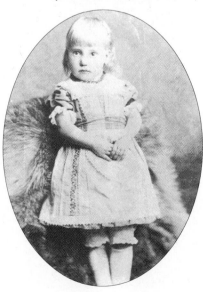

Agnes Bayne (Thompson), 1886. (Tom Bayne)

Wedding of Susannah Armstrong and John Elford, 1885.
(Collen Andrews)

The Reeve family, 1885.
(Jill Jones)

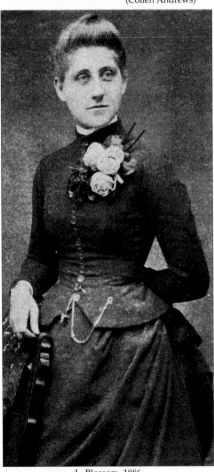

L. Blossom, 1886.
(Sara Robertson)

Fred Barber, 1885. (Sara Robertson)

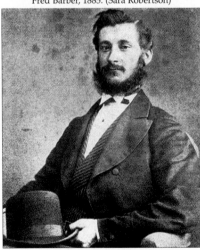

Albert White, c. 1886. (Nan McComber)

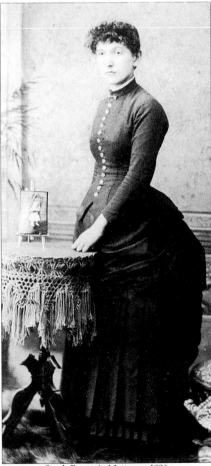

Sarah Fountain Matteson, 1886.
(Karen Ellsworth)

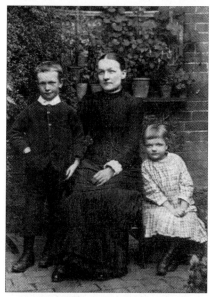

Alice Brewer Smith, Charles Smith and Lucy
Alice Smith, 1885. (Phyllis Libby Glynn)

The Kuhns family, 1886.
(Sue Melvin)

Mr. and Mrs. John Zeller, 1888. (Janet Foisset)

Frederic H. Calkins, 1888.
(Barbara A. Stroup)

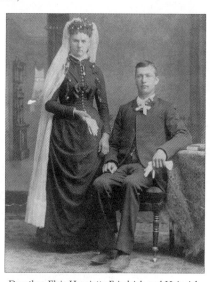

Dorothea Elsie Henriette Friedrick and Heinrich
Carl Mohrs, 1887. (Annette Dorey)

Almon G. Coburn, 1885. (Liz Schmidt)

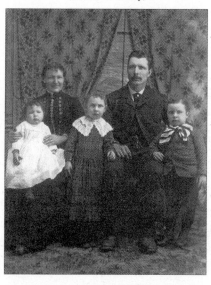

George, Sarah, M. Alice, Royal William, Ethel L.
Harwood, 1889. (Phyllis Libby Glynn)

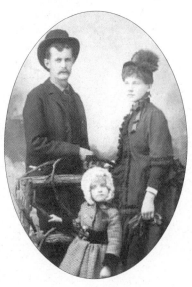

Stephen, Ella and June Phay, 1887.
(Dawnee McCulley)

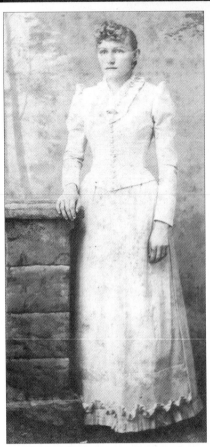

Annie Catherine Crowell, 1889.
(Karen Monsen)

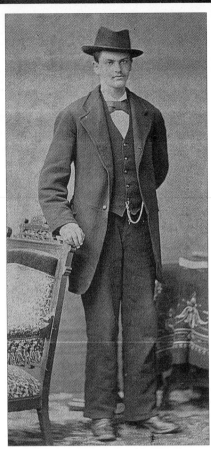

William Henry James, 1885.
(Paul J. James)

Auntie Winslow, 1888.
(Barbara A. Stroup)

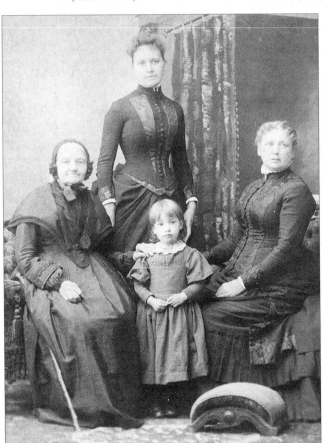

Sallie Spink (standing) with child Olive, mother and grandmother, 1888.
(Robert Cheesman)

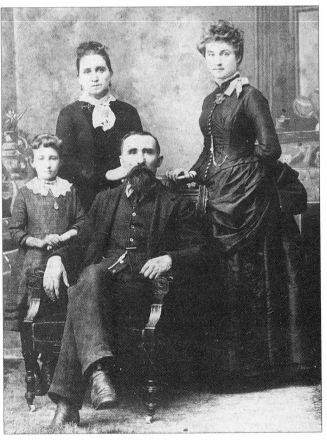

The Goforth family, c. 1888.
(Thomas P. McKenna)

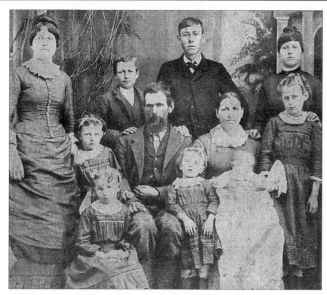

Margaret Ellen (Perry) McCullough and William V. McCullough family, 1885. (Eleanor Duree)

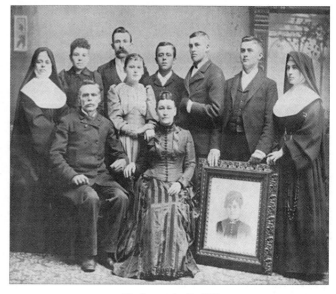

The Jacques family, 1887. (Jacquie Scherr)

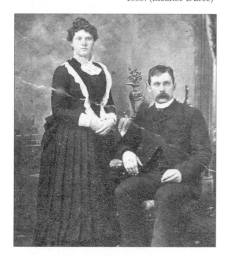

Eliza Augusta and William John Yates, 1886. (Pam Moughton)

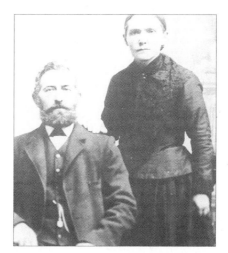

Jakob and Pauline Eilbert, c. 1885. (Delores E. Schleret)

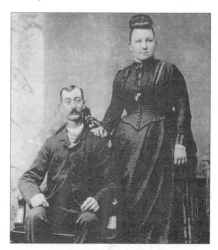

Fredrick John Williams and Loretta May Gilbert Williams, 1889. (Karen L. Chabot)

Pearl and Alexander Robertson, 1887. (Dorothy Woliung)

Mary Elizabeth and Agnes McCallum, 1889. (Kay White)

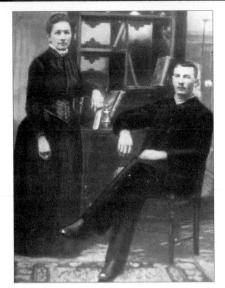

Unidentified subjects, 1889.
(Avanelle Cook)

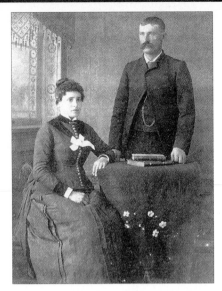

Edith Viola (Baughman) Pfalser and John Pfalser,
1888. (Ivan L. Pfalser)

Clara and Reuben Moore, 1886.
(Marilee Moore Helton)

Mary, Leroy and Ida L. Stanford, 1889.
(Kathleen K. Graham)

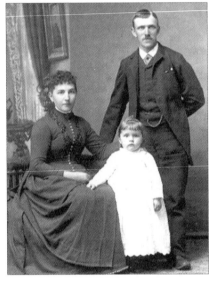

The Nelson family, 1888.
(Elsa Moberg Gilliland)

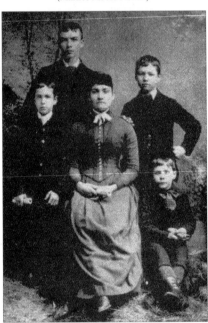

Archie, Ira, Addie, Thomas and John Shapbell,
1888. (N. June Shapbell)

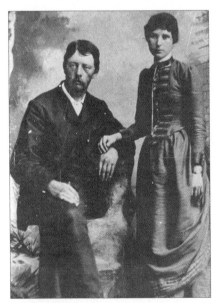

Wedding photo of Edgar Elsworth Coulter and
Mary Elizabeth Cronk, 1887. (Sandra J. Coulter)

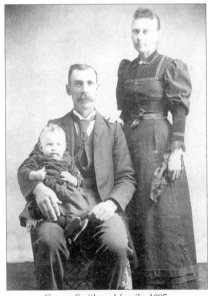

George Smith and family, 1885.
(Sandra J. Coulter)

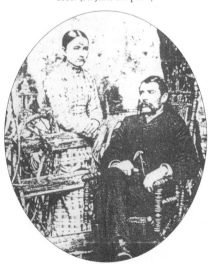

John R. Sommer and May E. Brook, 1888.
(Charles Sommer)

Elias Fegley, 1890. (Barbara L. Volpe)

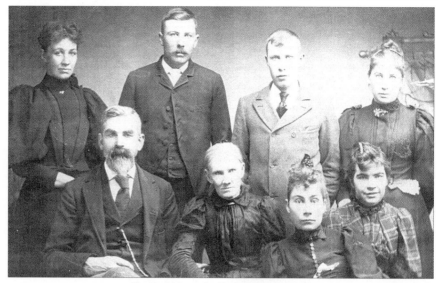

The David Evans family, 1890. (Linda Evans)

George Frederick Easley and Nell Easley, 1891.
(Pamela Hart)

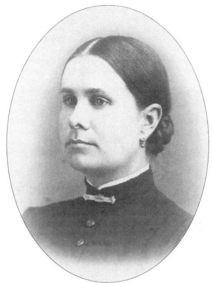

Ann Marie Modahl, 1890.
(Ken Harper)

Jennette Cordelia Dean Krafft, 1894.
(Dean Blackmar Krafft)

Unidentified family, East London, South Africa, 1894.

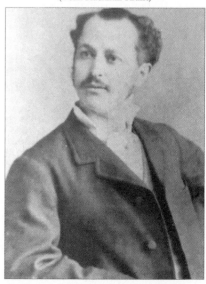

Lorenzo Sedici, 1890. (Mary M. Holland)

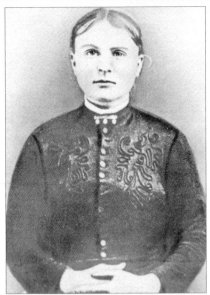

Eliza Jane Norwood Nelson, c. 1890.
(Bruce Burkeen)

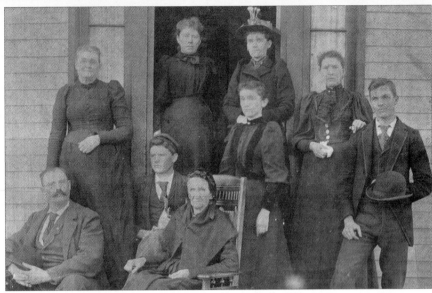

The Joseph Hamilton Hopper family, 1890.
(Joan Leach)

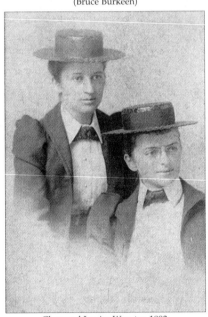

Clara and Louise Wooster, 1892.
(Clara Obern)

Unidentified subject, 1892.
(B.C. Bower)

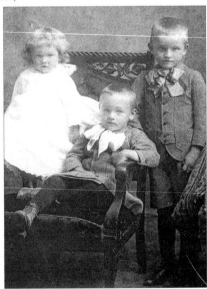

Jack, Harold and Eugene Hockin, 1891.
(Nora Hockin)

Augusta Powitzky Elgin, 1892.
(Tanya G. Kloesel)

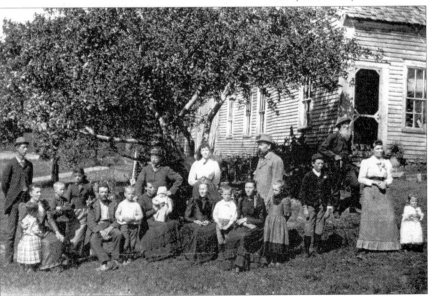

The George Herbert Libby family, c. 1890.
(Phyllis Libby Glynn)

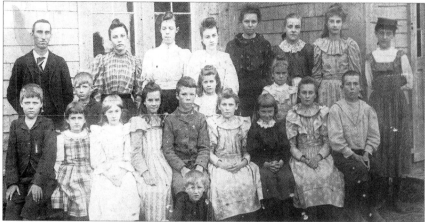

Unidentified subjects, c. 1892. (Elizabeth Crouch)

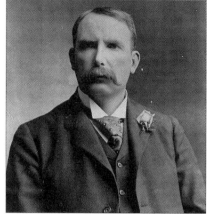

Edward Frederick Clarke, 1891. Mayor of Toronto 1888-1891. (Roger Clarke)

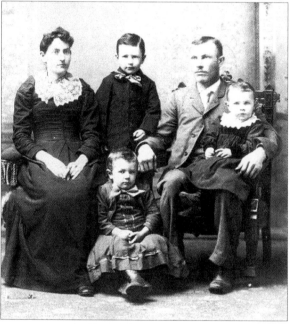

The Lewis family, 1892. (Linda Evans)

Heinrich Hett, 1892. (Nancy H. Stock)

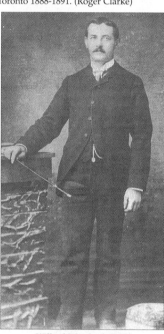

Willard Woodard, 1890. (Shirley Ramsay)

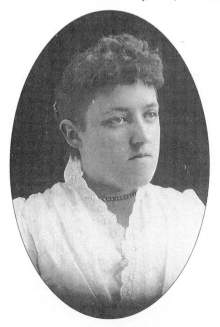

Unidentified subject, 1892. (B.C. Bower)

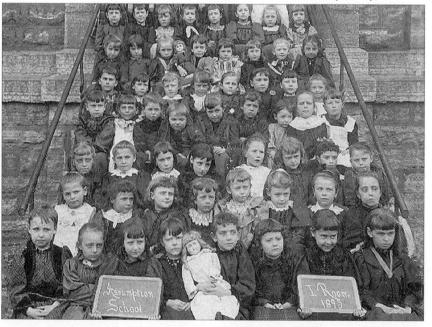

Assumption Catholic Girls School, 1893. (Lynne Slater)

Allen Lemon, 1892.
(Sara Robertson)

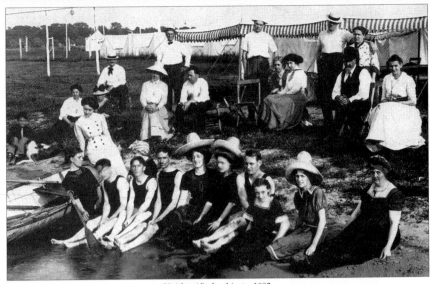

Unidentified subjects, 1892.
(Donna Potter Phillips)

Osa Ola and Mary Ann Beason Collins Barton,
1891. (Augusta Griffin Slagle)

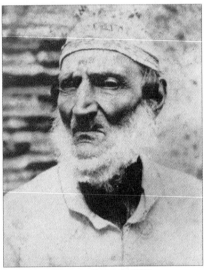

Vincenzo Baccante, 1892.
(Nick Baccante)

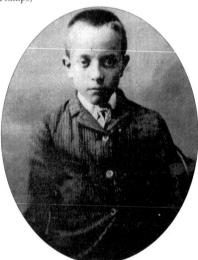

George Walker Larkin Thomas, 1893.
(Phyllis Libby Glynn)

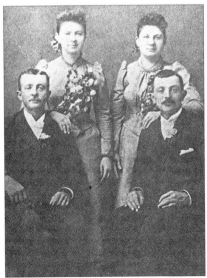

Unidentified subjects, 1892. (Joan M. Hanshew)

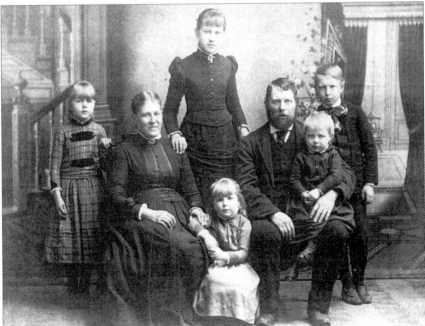

The Walter John Harwood family, c. 1890. (Phyllis Libby Glynn)

John T., Elizabeth M. and Ida F. Liebl, c. 1893.
(Mary B. Parrish)

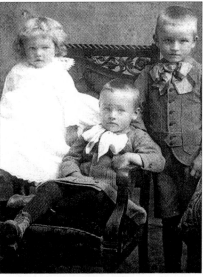

Jack, Harold and Eugene Hockin, 1891.
(Nora Hockin)

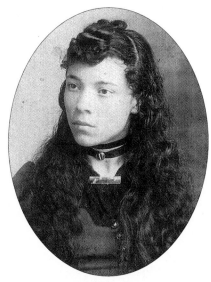

Mary Lytle, 1892.
(Elizabeth J. Hughes)

Unidentified subjects, 1891. (Marguerite Main)

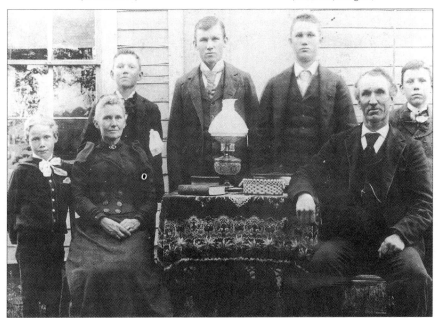

The Tracy family, 1894. (Chris T. Spencer)

Porter W. and Frank E. Bunney, 1890.
(Stephanie Sedberry)

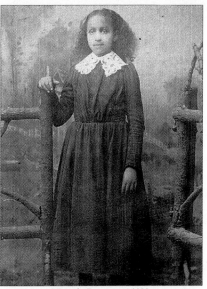

Marcela Berryman, 1890.
(Elizabeth J. Hughes)

Emma and Leslie Mark Randall Kerrison, 1894.
(Elizabeth Crouch)

Frederic Russell Robinson and family, 1894.
(Mary M. Holland)

Marie Louise Tisdelle, c. 1891.
(Paul Tisdale Baptista)

Julia Lytle, 1894.
(Elizabeth J. Hughes)

Peter Fisher Shapbell and family, 1893.
(N. June Shapbell)

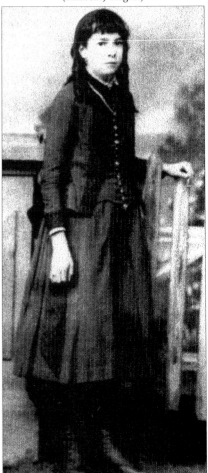

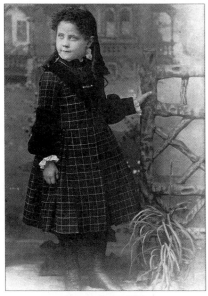

Claudia Pefley, 1890.
(Virginia Bradford)

Unidentified subject, 1891.

Nellie Wade Brown Shapbell, 1890.
(N. June Shapbell)

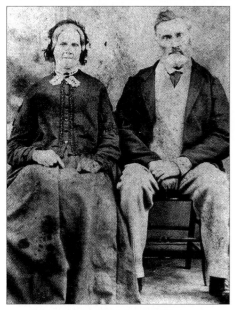

Unidentified subjects, 1890.

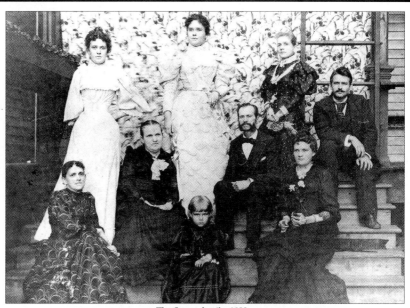

The Stuart family, 1893.
(Thomas Stuart Tullis)

Unidentified subject, 1890.

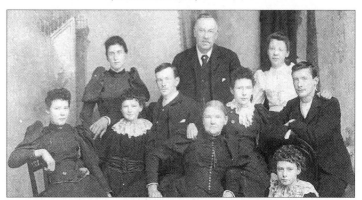

Robert Henry Thomlinson and family, 1892.
(Mary M. Holland)

Unidentified subjects, 1891.
(Gladys Lundal)

Unidentified subjects, 1891.
(Lyn C. James)

Unidentified subjects, 1897.
(Lyn C. James)

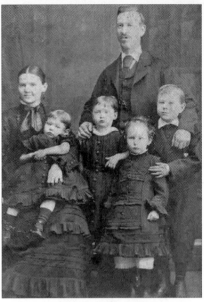

Unidentified subjects, 1898.
(Mary M. Holland)

Johan and Elise Widmayer, 1897.
(Delores E. Schleret)

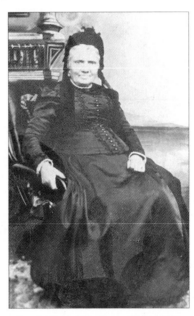

Ann Pattinson Thomlinson Roberts, 1899.
(Mary M. Holland)

Samuel Berryman, 1899.
(Elizabeth J. Hughes)

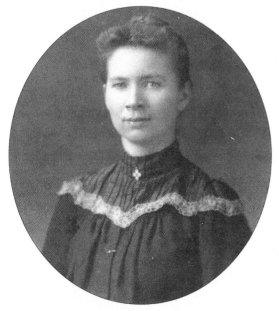

Unidentified subject, 1896.
(Joan M. Hanshew)

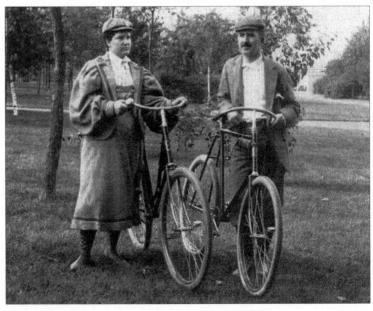

Mr. and Mrs. Robert F. Griffis, 1895.
(Leona M. Carder)

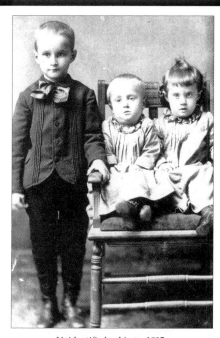

Unidentified subjects, 1895.
(Donna Potter Phillips)

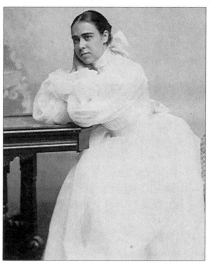

Frances C. Knapp, 1896.
(Marguerite Main)

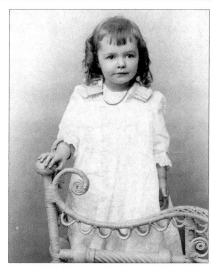

Bertha Tripp (Robinson) Lang, 1895.
(Lorna E. Hill)

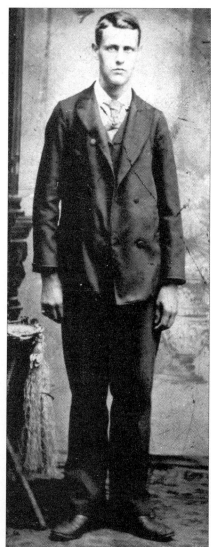

George Noel Tisdale, c. 1897.
(Paula Tisdale)

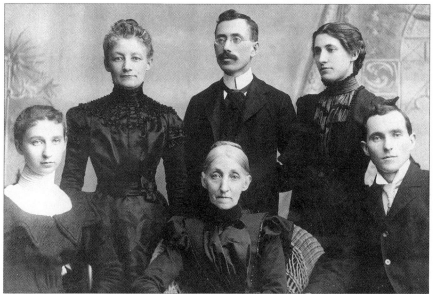

The Wallace family, 1895. (Chris T. Spencer)

Alice and Theodore Willard, Sr., 1898.
(Betty Jaekle)

Emma and George Morris, 1898.
(Kathleen Maher)

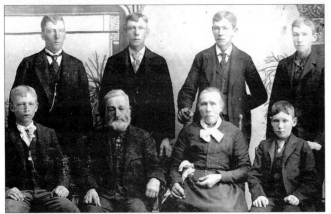

Family of Gulbrand Gulbrandson Raastad (with beard), 1896.
He was killed by a bull in 1896 and it is believed that this family portrait
was taken after his death. (Ken Harper)

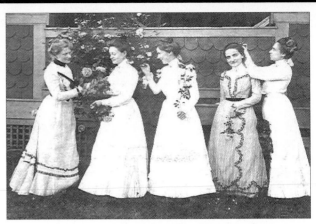

Unidentified subjects, 1897.
(Marguerite Main)

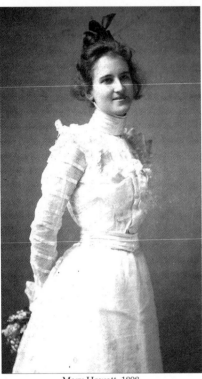

Mary Howatt, 1898.
(Bill Savage)

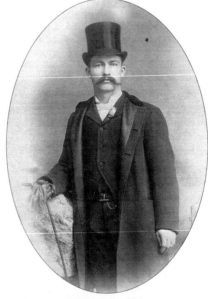

George Lytle, 1898.
(Elizabeth J. Hughes)

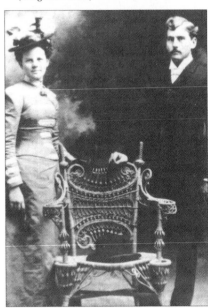

A.W. and Josie Waddill, 1898.
(Dorothy L. Baker)

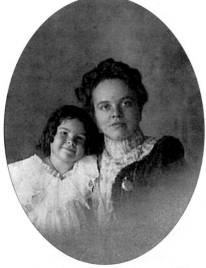

Maude and Emilie Bilodeau Mayotte, 1898.
(Jacquie Scherr)

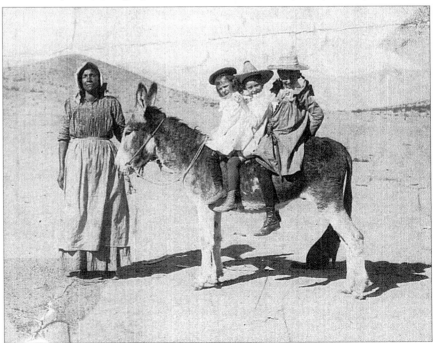

Eliza Jane Lytle Berryman and children, 1898.
(Elizabeth J. Hughes)

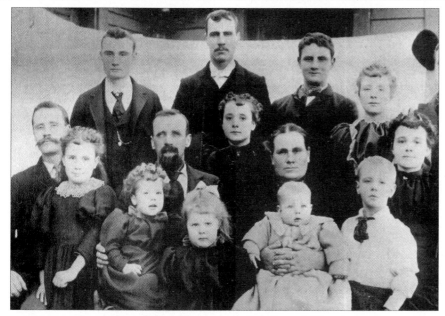

Philip and Mary Miller and family, 1896. (Jeannette Wynne)

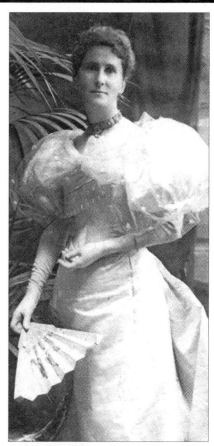

Annie Watson Galloway (McNeill) Cooper, 1897.
(Nora Hockin)

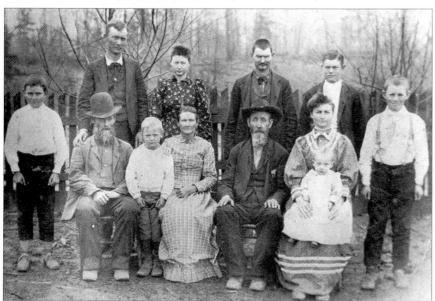

The Obediah Hardin and Henrietta Fredeking Hardin Family, c. 1895. (Carol Sissin Regehr)

Mr. Daniels, Nellie Harwood Elder, Jack Elder,
Julianna Guy Harwood Daniels, (infants) Burton
and Edna Elder, 1895. (Phyllis Libby Glynn)

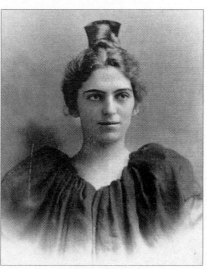

Mabel Wooster, 1895.
(Clara Obern)

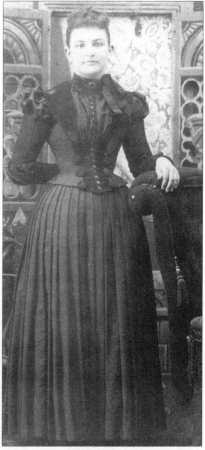

Unidentified subject, 1895.
(Avanelle Cook)

Alfred and Arthur Leech in Hampshire
Volunteer's uniforms, father Sibbs in
background, 1897. (Louise Richard)

Lovell Clark, 1896.
(Eugene Clark)

Goldie, Clarence, Alberta, Percy and James
Hughes, 1899. (Elizabeth J. Hughes)

John and Linnie Elmetta Andress, 1895.
(Sara Barteau)

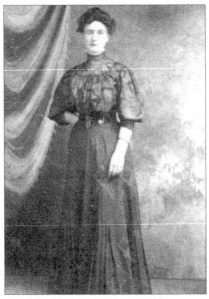

Unidentified subject, 1895.
(Kay White)

Clara Koch, 1899.
(Nancy H. Stock)

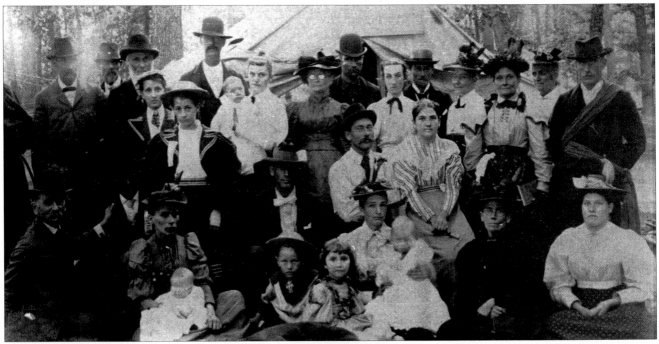

The Lemon family, 1896. (Sara Robertson)

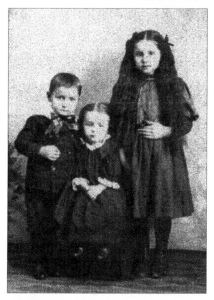

Unidentified subjects, 1897. (Avanelle Cook)

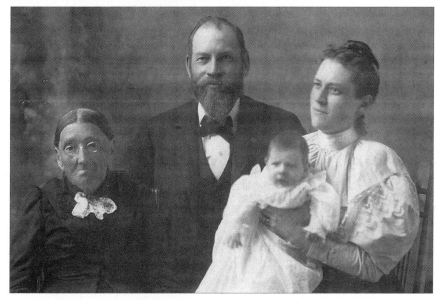

The Dean family, 1896. (Dean Blackmar Krafft)

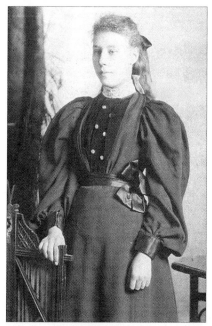

Emily, 1899. (Kat Stubbs)

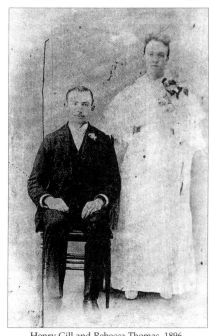

Henry Gill and Rebecca Thomas, 1896.
(Phyllis Libby Glynn)

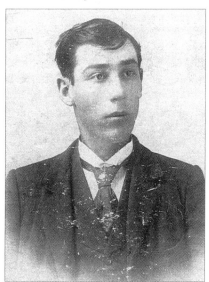

Maxim St. Louis, 1899. (Diana Kelly)

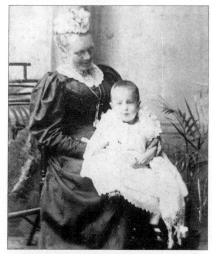

Elizabeth Robinson Randall Abraham holding
Leslie Mark Randall Kerrison, 1895.
(Elizabeth Crouch)

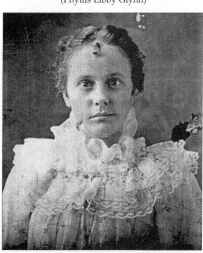

Mary E. Cromwell Potter, 1896.
(Rex J. Givens)

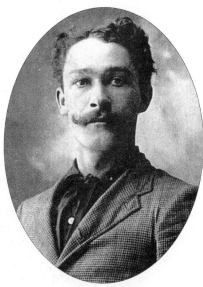

Hayes Lytle, 1899.
(Elizabeth J. Hughes)

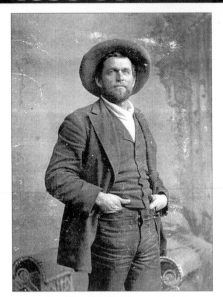

Albert Duree, 1897. (Eleanor Duree)

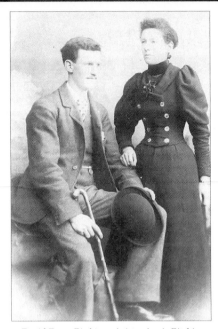

David Dunn Ritchie and sister Annie Ritchie, 1898. (Mary M. Holland)

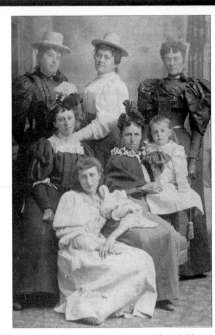

Emeline Tarbox Reed Burnham and her children, 1895. (Liz Brown)

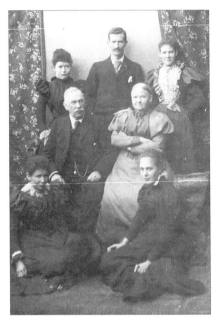

Robert Henry and Margaret Thomlinson with Mary, Hannah, Mary Jane, M.F. Parker and David Dunn Ritchie, 1898. (Mary M. Holland)

Dwight Lemon, 1896. (Sara Robertson)

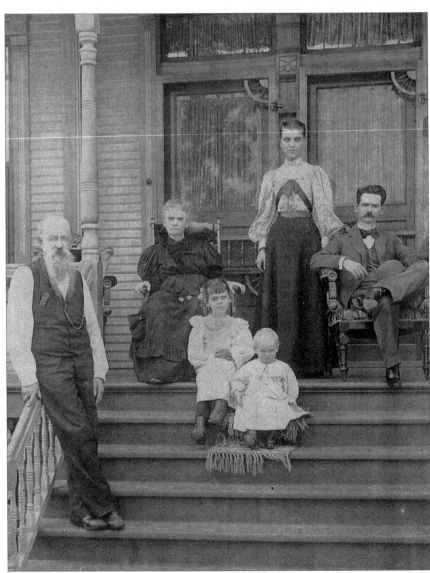

Unidentified subjects, 1898. (Donna Potter Phillips)

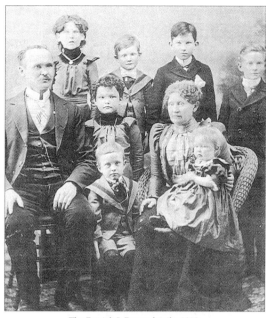

The Patrick J. Regan family, 1899.
(Kathleen Maher)

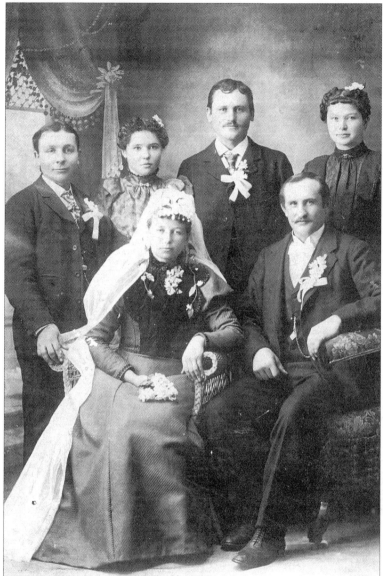

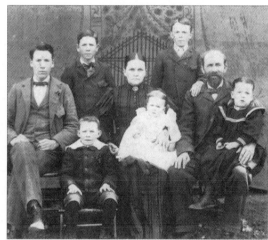

The Gunter family, 1897.
(Betsy Gunter Johnson)

Anastasia Hable (bride) and Joseph Hirsch (groom), 1899. (Lucille Varsho Simpson)

Arthur and Elizabeth (Saunders) Leech, 1897.
(Louise Rustad)

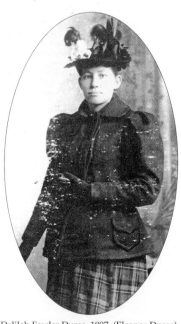

Delilah Fowler Duree, 1897. (Eleanor Duree)

Ralph Victor Kerrison, c. 1901.
(Elizabeth Crouch)

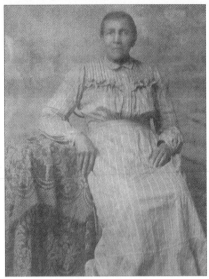

Eliza Jane Lytle, 1900.
(Elizabeth J. Hughes)

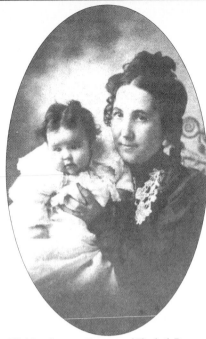

Ella Nora Sampson Parsons and Elizabeth Parsons,
1902. (Kay White)

Roma Luella Griffis, 1903.
(Leona M. Carder)

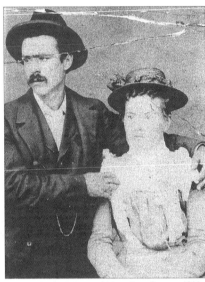

Octave Dumont, Jr. and Mary Jane Bennet, 1900.
(Shirley Ramsay)

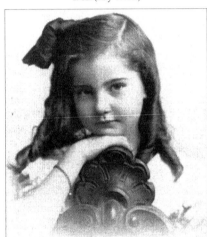

Leona Ester Griffis, 1902.
(Leona M. Carder)

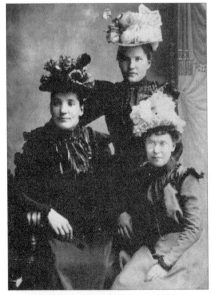

Jenny Skille, Loive Gallager and Helen
Anderson, 1900. (Linda J. Libician)

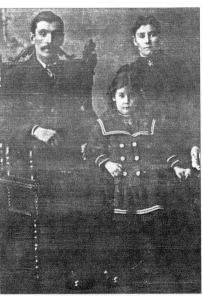

Duncan MacGregor, Emma Quait and daughter
Marion, 1903. (Shirley Ramsay)

Orleta G. Berryman, 1902. (Elizabeth J. Hughes)

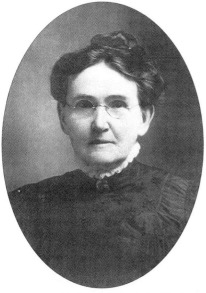

Anna Bradford, 1902. (Virginia Bradford)

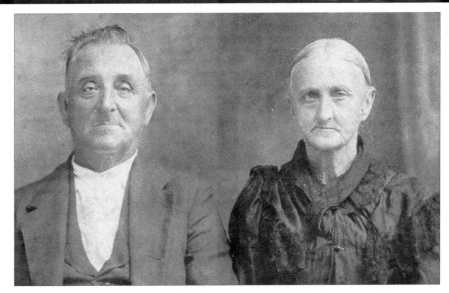

James Prince and Catherine Elizabeth Burkeen, c. 1900.
(Bruce Burkeen)

Zeffie Johnson Coleman and Burch Franklin
Coleman, 1903. (Clifford B. Johnson)

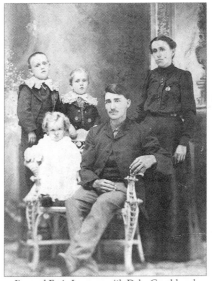

Jim and Essie Lawson with Dale, Gerald and
Lester, 1900. (Jim Lawson)

Thomas Shapbell, 1901.
(N. June Shapbell)

Rebecca Cordelia Pond Dean, 1902.
(Dean Blackmar Krafft)

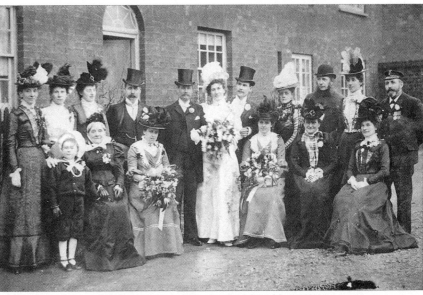

Wallace Crouch and Georgina Randall Wedding, 1901.
(Elizabeth Crouch)

Lena Melissa Aldrich and Minnie Corbett,
c. 1904. (Valerie Josephson)

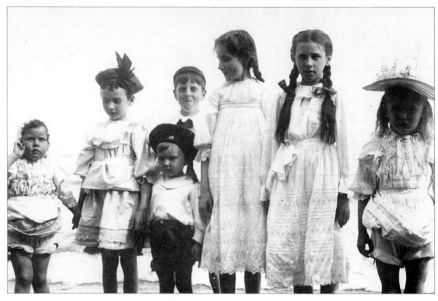

Unidentified subjects at Lake Ontario, c. 1900. (Robert Cheesman)

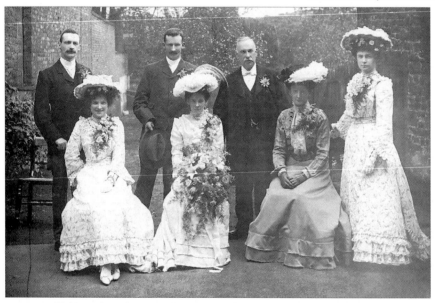

Wedding of David Dunn Ritchie and Mary Thomlinson, 1902. (Mary M. Holland)

Unidentified subject, 1900.
(Kimberly Paradis Grimes)

William Loughran, 1902. (Edwin Hearn)

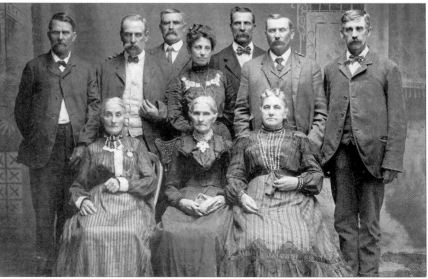

The Owen Barnes family, 1904. (Jim Cruth)

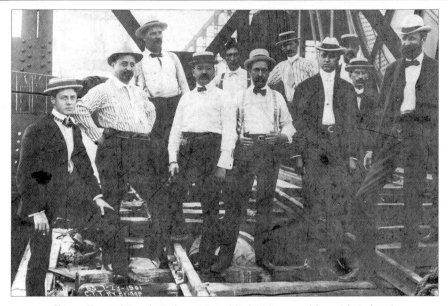

Chicago Terminal Transfer Railway 'Master Minds'. Man second from right in front is Alfred "Fred" Paradis, 1901. (Kimberly Paradis Grimes)

Tom and Lida Warne, 1903. (Kelly Hokkanen)

Johanna Magyar and family, c. 1904. (Valerie Josephson)

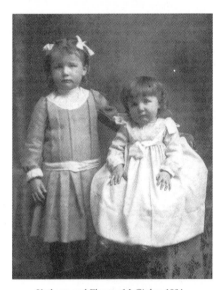

Kathryn and Eleanor McGinley, 1904. (Maureen Bruner)

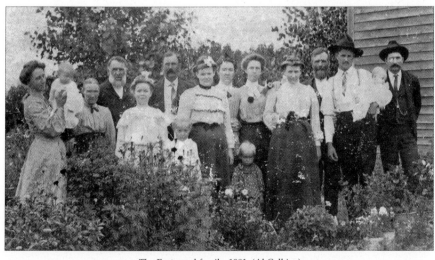

The Eastwood family, 1901. (Al Calkins)

Paul Raddatz, Jr. and dog, Scholle, 1904. (Ramona Bishop)

B. K. Baird, c. 1902.
(Dorothy L. Baker)

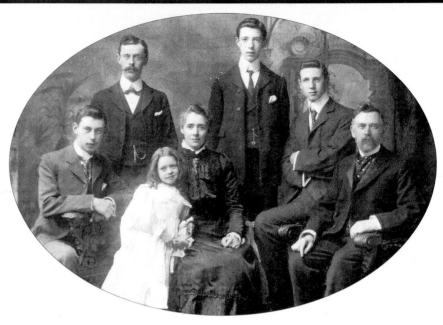

Unidentified subjects, 1902. (Kat Stubbs)

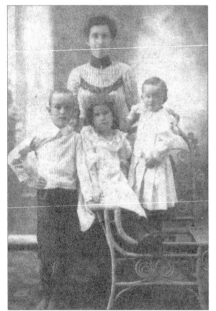

Unidentified subjects, 1903. (Kay White)

Dwight and Lulu Lemon, 1900.
(Sara Robertson)

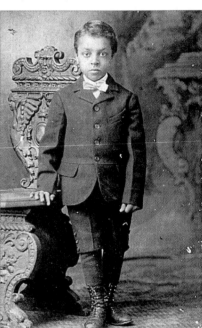

James T. Hughes, 1903. (Elizabeth J. Hughes)

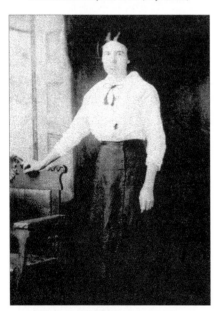

Carrie Esther Erb Klingerman, 1900.
(N. June Shapbell)

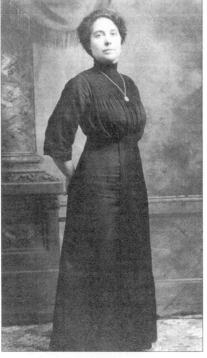

Minnie Lovisa (Stone) Macomber, c. 1903.
(Nan McComber)

Gertrude May Callahan, 1903.
(William S. Perry, Jr.)

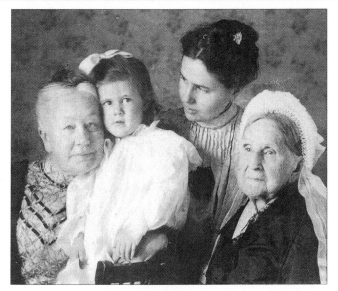

Unidentified subjects, 1903.
(Clara Obern)

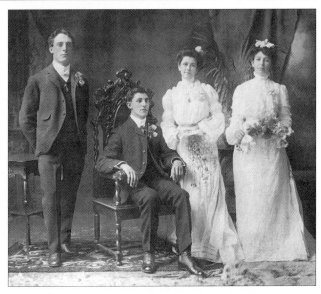

August Colleur, Albert LaMarche, Elizabeth (Gardner) LaMarche and
Victoria (Gardner) Colleur, 1903. (Joseph H. LaMarche)

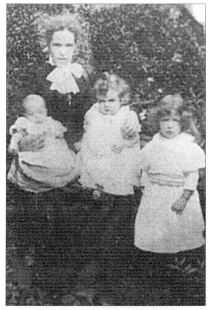

Emily Thompson with unidentified
children, 1902. (F. Nelson)

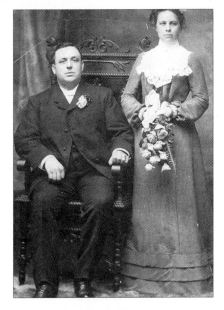

P. Joseph and Anna Hess, 1902.
(Debbie Hoffman)

Frank Callahan, 1903.
(William S. Perry, Jr.)

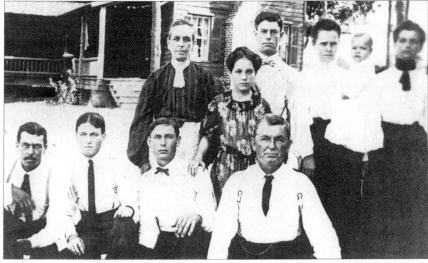

The James W. Wood family, c. 1904. (Teddy L. Roberson, Jr.)

Unidentified subject, 1901. (Clara Obern)

Annie, Mabel and Lena Parker with Mabel's daughter, 1900.
(Robert Cheesman)

Andrew Thompson, Isabella Crerar and Carson, 1900.
(Shirley Ramsay)

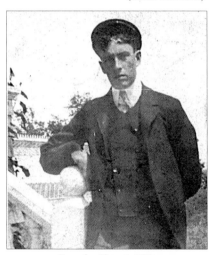

Eversden Howatt, 1900.
(Bill Savage)

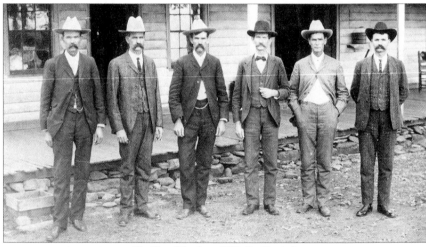

The Harrell brothers, 1904. (Jim Denton)

Percy C. Hughes and Goldie Hughes, c. 1902.
(Elizabeth J. Hughes)

Elsie Vivian Sherwood, Ellsworth Braden Sherwood and Muriel E. Sherwood, 1900.
(Harry W. Sherwood)

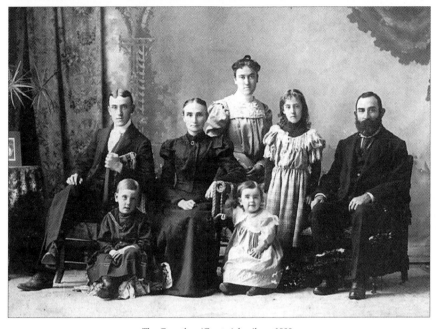

The Guenther (Gunter) family, c. 1900.
(Nancy Carswell)

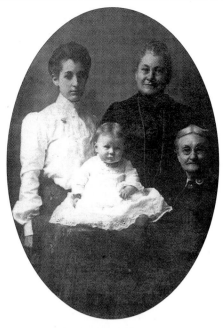

Bessie Richardson Winchell, Nora Lemon
Richardson, Jackie Winchell and Hannah Spicer
Lemon, 1904. (Sara Robertson)

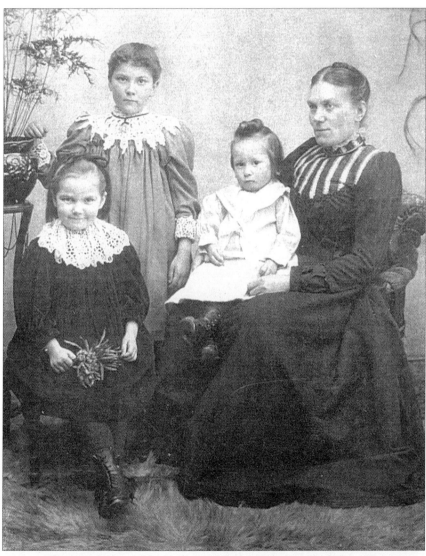

Minnie Caroline Susan (Cheese) White and Charles, Mildred Jenny and Lilias, 1900.
(Nan McComber)

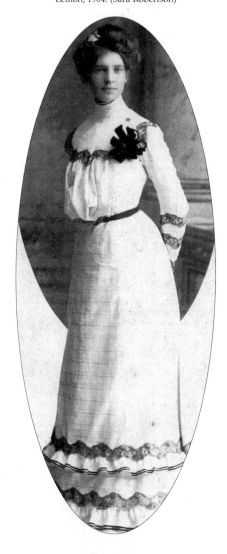

Unidentified subject, 1901.
(Kimberly Paradis Grimes)

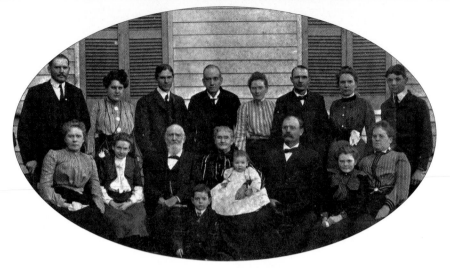

The Joseph Hopper family, 1903.
(Joan Leach)

R. R. Baird, c. 1902.
(Dorothy L. Baker)

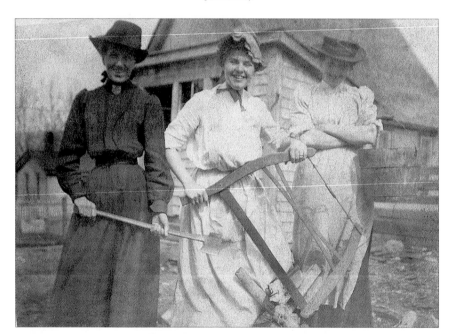

Sara Josephine (Austin) Callahan (center), 1903.
(William S. Perry, Jr.)

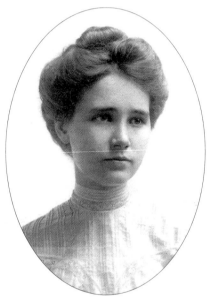

Unidentified subject, 1902.
(Lyn C. James)

Roma Luella Griffis, multiple exposure, 1903.
(Leona M. Carder)

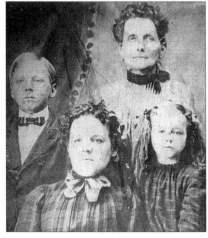

Members of the Parrish Family, 1902.
(Mary Nell Burnett)

Gerald and John Howatt, 1905.
(Bill Savage)

Unidentified subjects, 1908.
(Lila Slaybaugh)

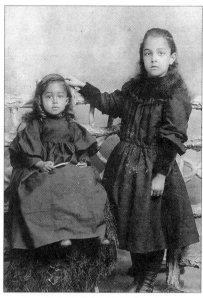

Orleta G. Berryman and Florence F. Berryman,
1905. (Elizabeth J. Hughes)

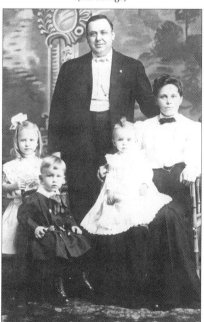

The P. Joseph Hess family, c. 1906.
(Debbie Hoffman)

Unidentified subjects, c. 1905.
(Robert L. Claggett)

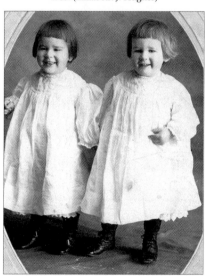

Gerald and John Howatt, 1907. (Bill Savage)

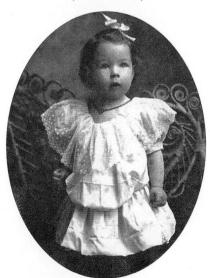

Pebble (Strong) Duree, 1906.
(Eleanor Duree)

Mary Ann Seel Windmeyer, c. 1905.
(Tanya G. Kloesel)

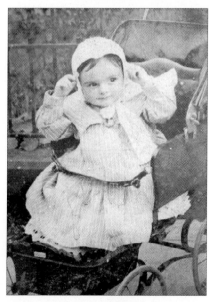

William Harold Husk, 1908.
(Linda J. Libician)

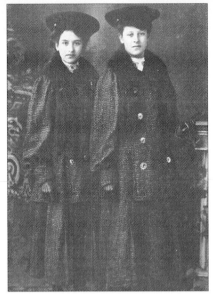

Margaret and Lile Jilbert, 1906.
(Gladys Lundal)

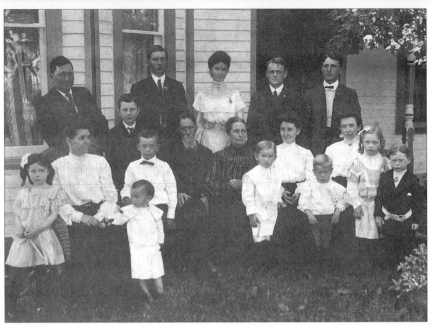

Unidentified subjects, 1905.
(Lyn C. James)

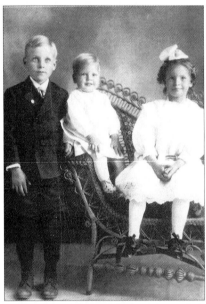

The Waddill children, c. 1907. (Dorothy L. Baker)

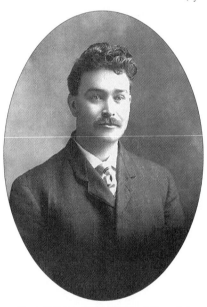

Frank Callahan, 1908. (William S. Perry, Jr.)

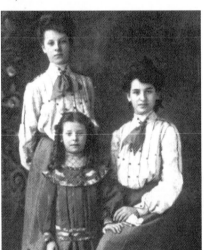

Unidentified subjects, 1905.
(Gladys Lundal)

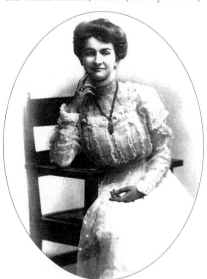

Florence Taylor Clancy, 1908.
(Janet Foisset)

John W. Erb, Sr., 1906. (N. June Shapbell)

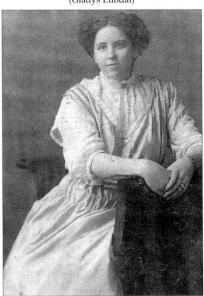

Isabelle Chapman, 1908.
(Patricia R. Lange)

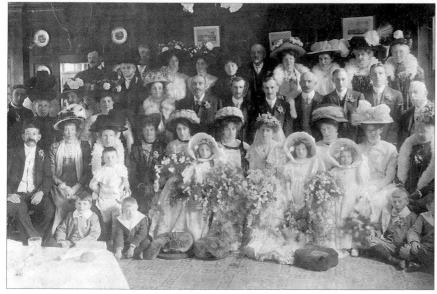

Wedding of Jane (Jean) Thomlinson to William Hurst, 1909.
(Mary M. Holland)

Florence F. Berryman, 1908.
(Elizabeth J. Hughes)

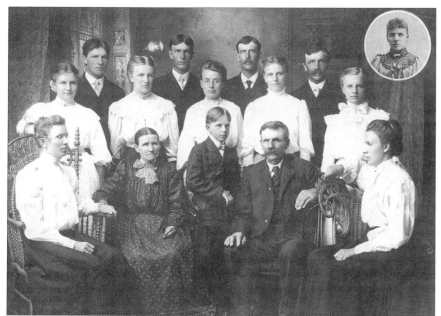

Herman and Amelia Borchardi family, 1906.
(Patricia R. Lange)

Ferdinand and Ida-Marie Scheel, 1908.
(Mary Scheel)

Matthew and Lucy Savage and their children,
1905. (Bill Savage)

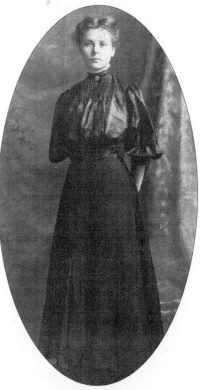

Bessie Nanie Potts Hastings, 1907.
(Karen L. Chabot)

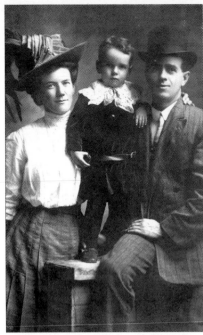

The King family, 1907. (Jane Hopkinson)

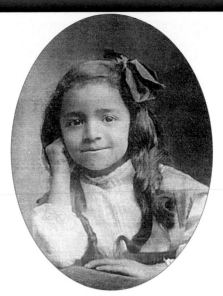

Orleta G. Berryman, 1907.
(Elizabeth J. Hughes)

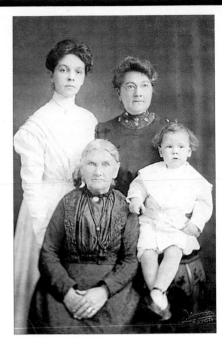

Oscar Munro Moberg (child) with mother,
grandmother and great grandmother, 1909.
(Elsa Moberg Gilliland)

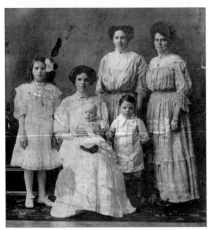

Eva Chapman, Jessica Chapman (holding)
Roland Howard, William Robert, Isabelle
Chapman, and Keziah Card Chapman, 1908.
(Patricia R. Lange)

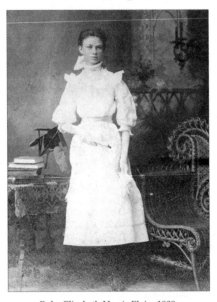

Ruby Elizabeth Harris Elgin, 1908.
(Tanya G. Kloesel)

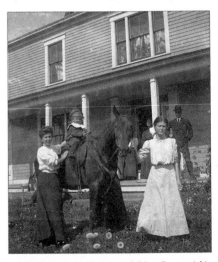

The Murray family homestead (New Brunswick),
1906. (William S. Perry, Jr.)

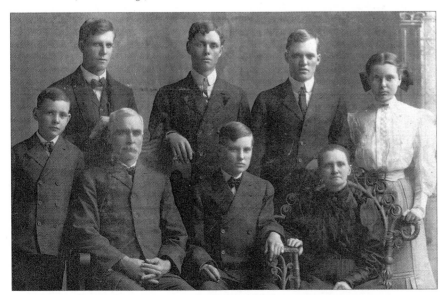

The Potts family, 1906.
(Karen L. Chabot)

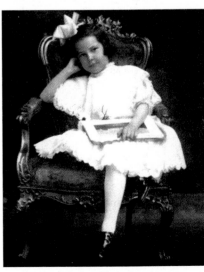

Joyce Griffis, 1907.
(Leona M. Carder)

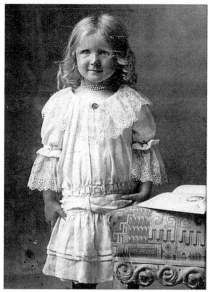

Mary Ann Hirsch, 1905.
(Lucílle Varsho Simpson)

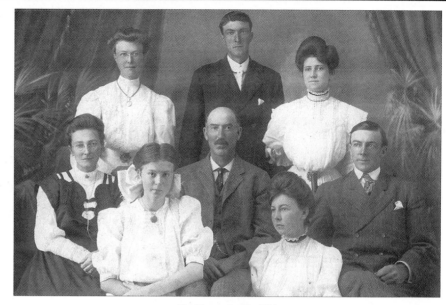

The Murray family, 1906.
(William S. Perry, Jr.)

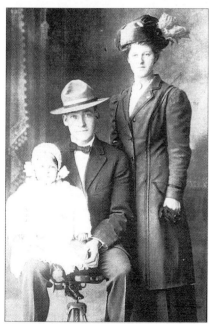

Charlie, Margaret and Lile Parsons, c. 1909.
(Gladys Lundal)

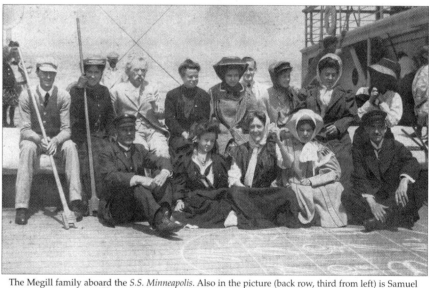

The Megill family aboard the *S.S. Minneapolis*. Also in the picture (back row, third from left) is Samuel Clements a.k.a. Mark Twain, 1907. (Charlotte Megill Hix)

Canon Victor Christian Albert FitzHugh and wife
Alice Vavara Georgina, 1906. (Nigel FitzHugh)

Margaret Thomlinson and daughters, c. 1905.
(Mary M. Holland)

Unidentified subject, 1906. (Joan M. Hanshew)

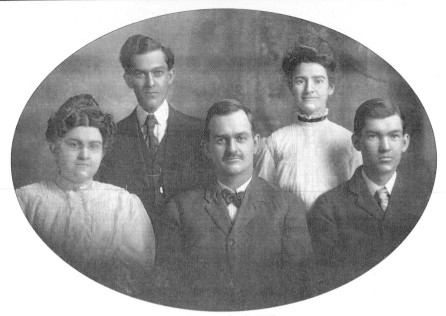

The Hastings family, 1907.
(Karen L. Chabot)

Mildred Stahlman, 1907.
(Marilee Moore Helton)

Charles Edward and Robert Andrew Stober,
1907. (Elizabeth Jastram)

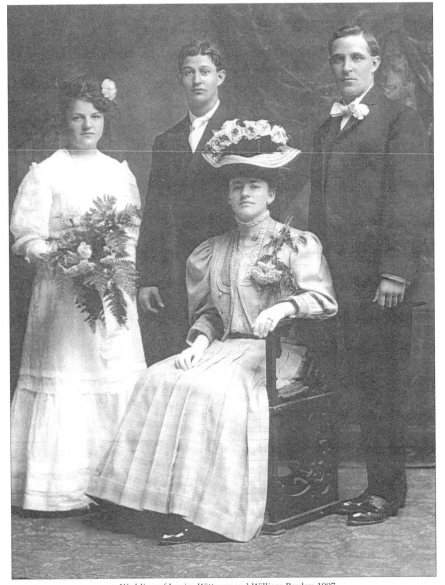

Wedding of Louisa Wittever and William Bouley, 1907.
(Janet Foisset)

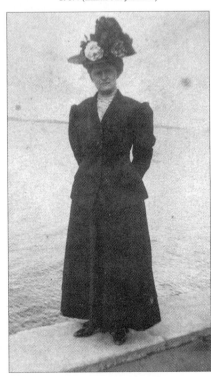

Anna M. L. Donoho, c. 1909.
(Debbie Hoffman)

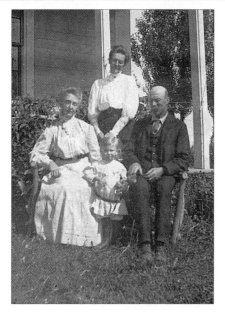

Mr. and Mrs. Murray with unidentified subjects, 1906. (William S. Perry, Jr.)

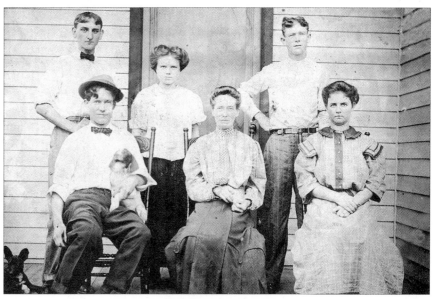

Mary Winsett and family, 1908.
(Betty Jaekle)

Audrey, 1907.
(Jane Hopkinson)

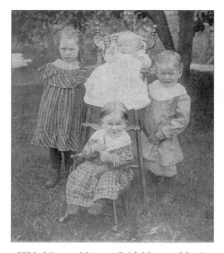

Hilda Minerva Manson, Orick Manson, Morris Roy Manson (in front), Park Manson (in high chair), 1905. (Lyall Manson)

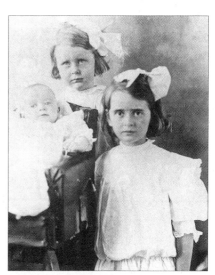

The Belyea sisters, 1908.
(Elizabeth Crouch)

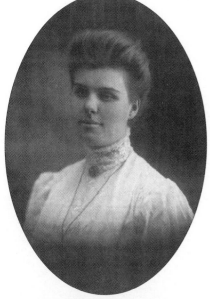

Josephine Callahan, 1908.
(William S. Perry, Jr.)

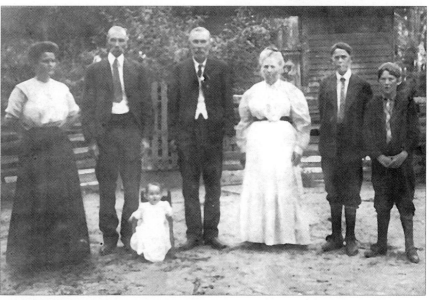

Thomas L. Brown and family, 1909.
(Betty Jaekle)

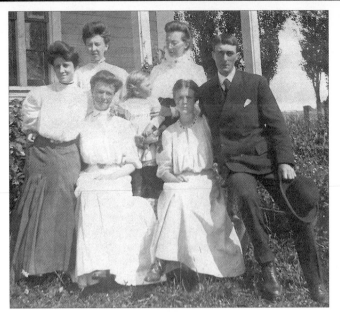

The Murray family in New Brunswick, 1906.
(William S. Perry, Jr.)

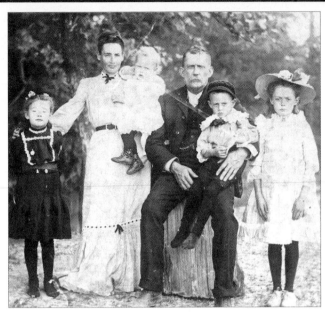

The Thompson family, 1905.
(Debbie Rose)

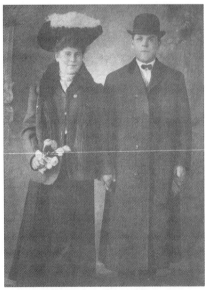

Monika (Borkowska) and Alexander
Gregorowicz, 1906. (John P. Dow, Sr.)

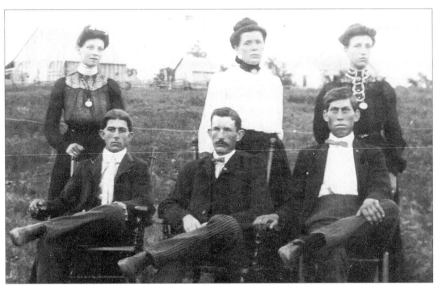

The Denton brothers with their respective wives or girlfriends, 1908.
(Jim Denton)

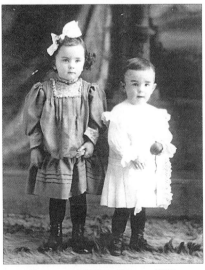

Florence and William Otterson, 1906.
(Mary Scheel)

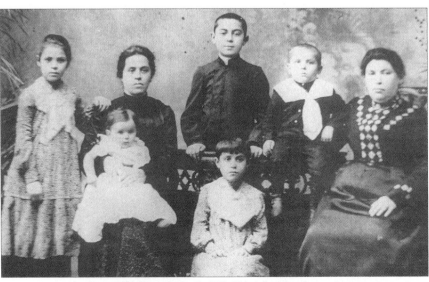

The Korunsky family, 1905. (Valerie Josephson)

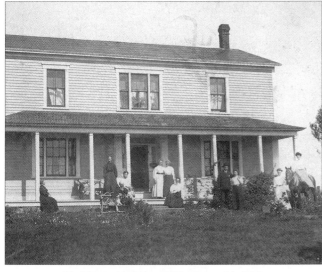

The Murray family home, New Brunswick, 1906.
(William S. Perry, Jr.)

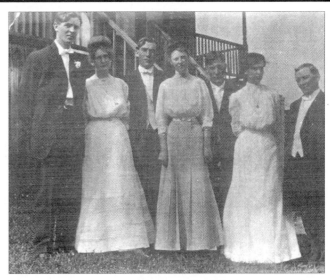

Wedding party of Charlie and Lile Parsons, 1907.
(Gladys Lundal)

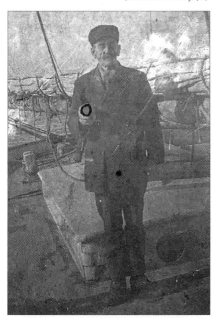

William Scott on board the St. John, New
Brunswick, Harbour Pilot Boat, 1909.
(Tom Bayne)

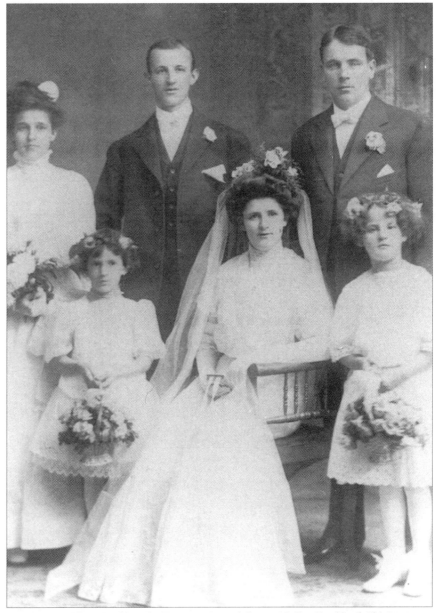

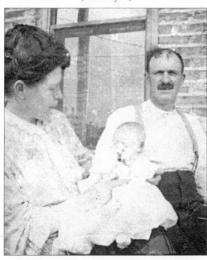

Elizabeth Jane Cleary McMahon, Helen and
Maurice McMahon, 1907. (B. Martin)

Ida Bowle, Gilbert Tremblay, John Harrington (groom), flower girl, Clare Tremblay (bride), Loretta
Trembly (Wayman), 1906. (John Wayman)

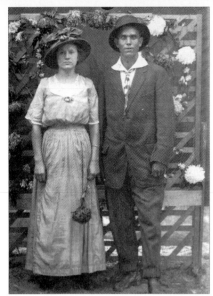

Henry and Nellie Goodrich, 1914.
(Debbie Rose)

Robert Lloyd Christmas, 1910.
(Ginger Christmas-Beattie)

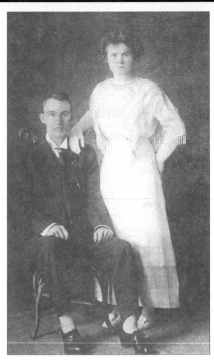

Harrison Gatewood Cline and Dora Anna
Kuhns, 1912. (Sue Melvin)

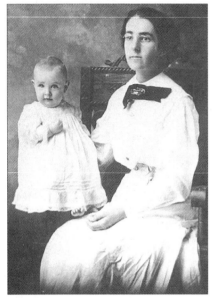

Fannie B. Barnhill Langdon holding James
Langdon, c. 1911. (Debbie Hoffman)

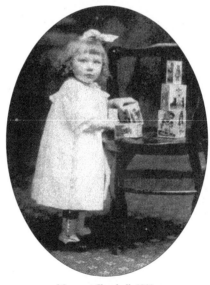

Margaret Shapbell, 1911.
(N. June Shapbell)

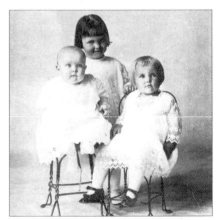

Margaret Eva Hastings Pierce (back), Jacob
Warren Hastings (l), Lillian Lucille Hastings
Williams (r), 1913. (Karen L. Chabot)

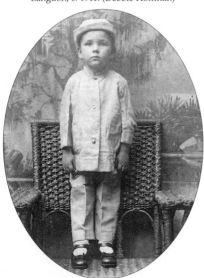

Theodore Willard, Jr., 1914.
(Betty Jaekle)

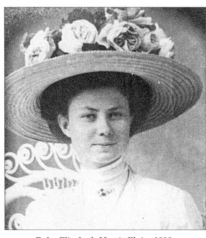

Ruby Elizabeth Harris Elgin, 1910.
(Tanya G. Kloesel)

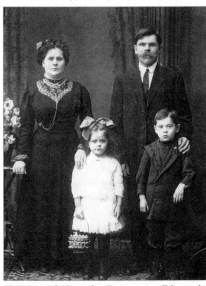

Monica and Alexander Gregorowicz, Edna and
Alex, Jr., 1913. (John P. Dow, Sr.)

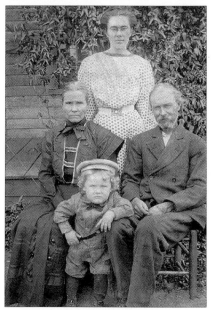

Unidentified subjects, 1912.
(Ronald G. Deal)

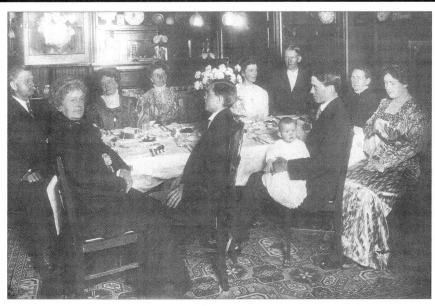

The Frank H. Bradford family, 1910.
(Virginia Bradford)

Robert Henry and Margaret (Roberts)
Thomlinson, 1912. (Mary M. Holland)

The Belyea sisters, 1912.
(Elizabeth Crouch)

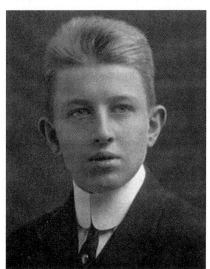

George H. Merril, Jr., 1913.
(A. Gaylord Oberin)

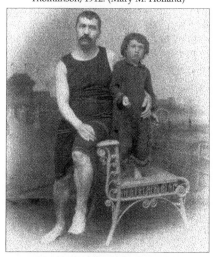

Thomas and William Shapbell, 1911.
(N. June Shapbell)

Theodore Willard, Jr., 1912.
(Betty Jaekle)

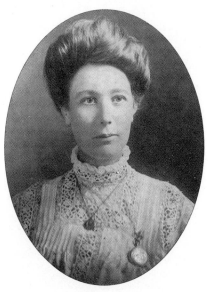

Mabel (Crossman) Colpitts, 1910.
(Donald F. Colpitts)

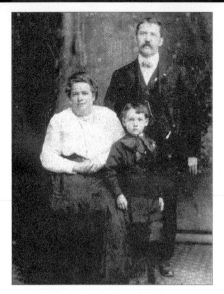

Nellie, Thomas and William Shapbell, 1912.
(N. June Shapbell)

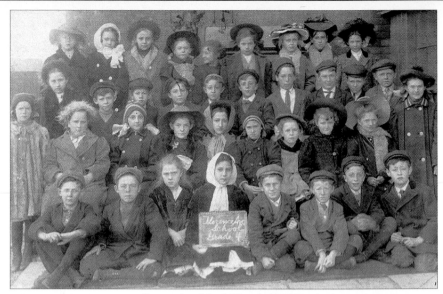

Florence Ave. School, Newark, NJ, 1910.
(Clara Obern)

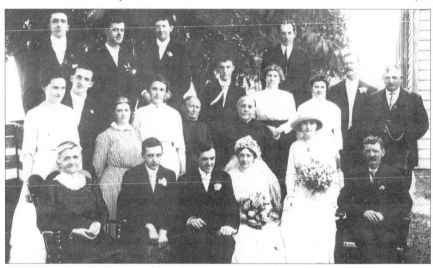

Wedding of James Albert Sneath and Catherine Flynn, 1913.
(Noreen Miatto)

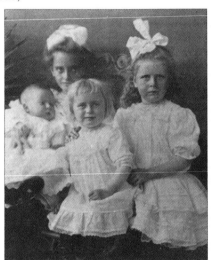

The Belyea sisters, 1910.
(Elizabeth Crouch)

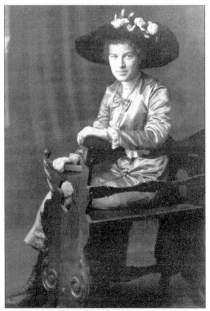

Harriet Higgins Lemon, 1912.
(Sara Robertson)

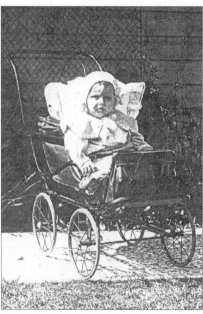

Unidentified subject, 1910.
(Joan M. Hanshew)

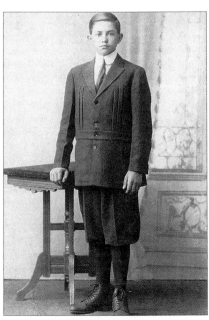

Julius Magyar, c. 1913.
(Valerie Josephson)

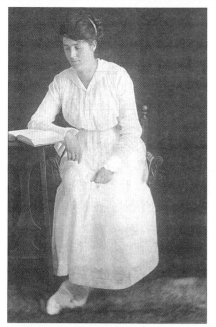

Lilias White, c. 1910. (Nan McComber)

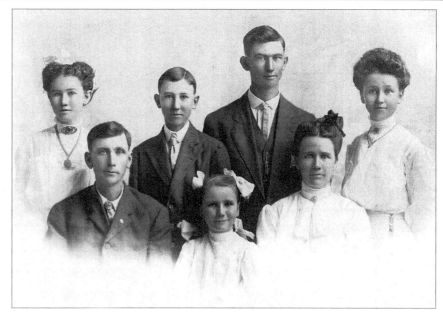

The Jackson family, 1910.
(Karen L. Chabot)

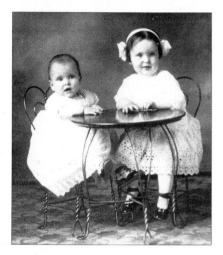

Lillian Lucille Hastings Williams and Margaret
Eva Hastings Pierce, 1912. (Karen L. Chabot)

Lavonne and Evelyn Thompson, 1910.
(Dan and Laura Heidman)

Philip and Dorothy Ormiston, 1912.
(Nigel FitzHugh)

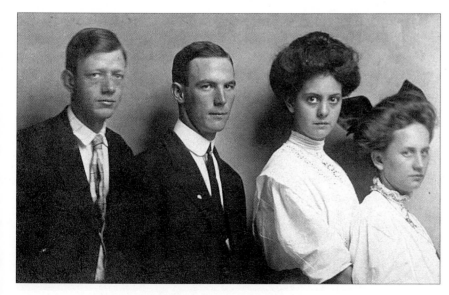

William Hauenstien, Ethel Moles and friends, 1910. (Kelly Hokkanen)

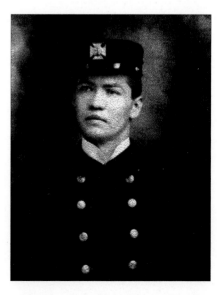

Unidentified subject, 1910. (N. June Shapbell)

Lela Hauenstien, 1911.
(Kelly Hokkanen)

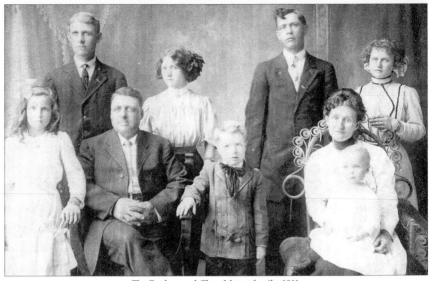

The Reuben and Clara Moore family, 1911.
(Marilee Moore Helton)

Willard Woodard, Ella May Adams, Franklin
Woodard and Angus Woodard (in dress), 1911.
(Shirley Ramsay)

Bertha Tripp (Robinson) Lang, 1910.
(Lorna E. Hill)

Unidentified subject, 1914.
(Paul Hoffman)

The Stift family, 1913.
(Kevin Nickel)

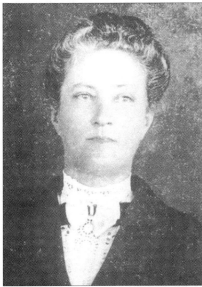

Mary Magdalene Sophia Lausen Harris, 1913.
(Tanya G. Kloesel)

Orrin Lester Chabot and Ella Mae Jackson
Chabot, 1910. (Karen L. Chabot)

Unidentified subjects, 1913.
(Lyall Manson)

Wendel Hoffman, 1910.
(Debbie Hoffman)

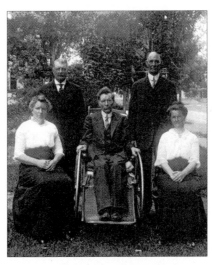

George G. Harwood, Walter John Harwood,
Henry Harwood, Martha Elder and Nellie Elder,
1914. (Phyllis Libby Glynn)

Harrison Gatewood Cline and Dora Anna
Kuhns, 1912. (Sue Melvin)

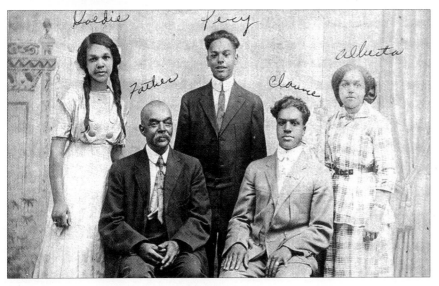

The Hughes family, 1913.
(Elizabeth J. Hughes)

Melvin Simmon and Alice May (née Tourtellotte)
Lindsley, 1913. (Jane M. Schumacher)

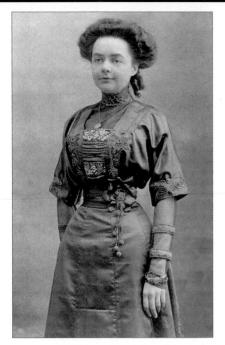

Bertha Tripp (Robinson) Lang, 1910.
(Lorna E. Hill)

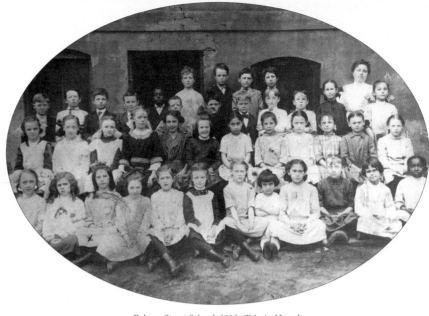

Palmer Street School, 1910. (Edwin Heard)

Four generations of the Frank H. Bradford
family, 1910. (Virginia Bradford)

A class in Newark, NJ, c. 1914.
(A. Gaylord Oberin)

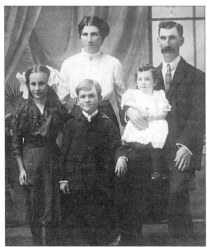

The Carswell family, c. 1912.
(Nancy Carswell)

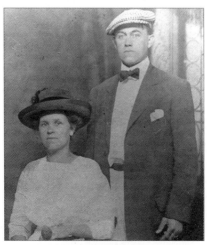

George E. Moyer, Sr. and Rebecca A. (Fegley)
Moyer, 1913. (Barbara L. Volpe)

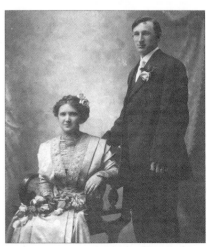

Clara and Charles J. Koch, 1910.
(Nancy H. Stock)

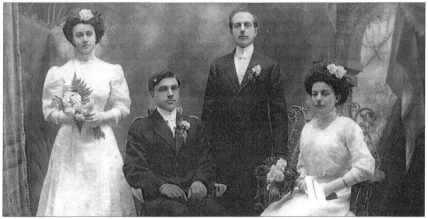

Wedding of Joseph Foisset and Lena Wittwer, 1911. (Janet Foisset)

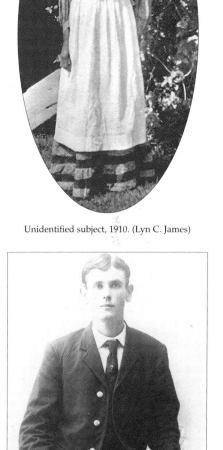

Unidentified subject, 1910. (Lyn C. James)

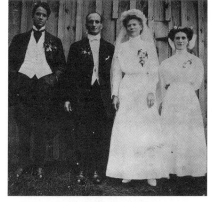

Unidentified subjects, 1910.
(Richard Balge)

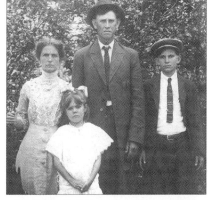

The Hester Huff (Deacon) and the Isaac Huff
family, 1914. (Kevin Nickel)

Alice White and husband Peter Smith, c. 1910.
(Nan McComber)

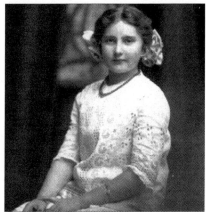

Leona Griffis, 1910.
(Leona M. Carder)

John Edward Elgin, 1912.
(Tanya G. Kloesel)

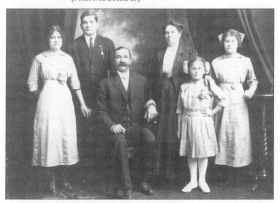

The wedding of Antonia Hom Teska and Matej Dusek, 1912.
Children are from Antonia's first marriage. (Paula Svatos Prium)

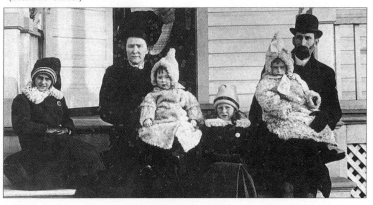

The Belyea family, 1911.
(Elizabeth Crouch)

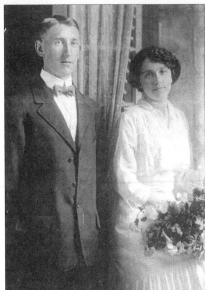

Charles Edward Richardson and Mabel Bertha Richardson (née Andrews), 1915. (Doris Redman)

Shannon and Leonard Lindenmeyer, c. 1917. (Debbie Hoffman)

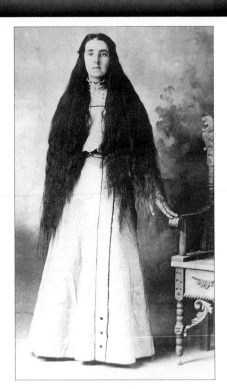

Fannie B. (Barhill) Langdon, c. 1916. (Debbie Hoffman)

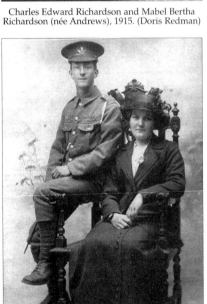

Mildred Jenny White and brother Charles Bicester, 1915. (Nan McComber)

George Robert Butler, c. 1919. (Nan McComber)

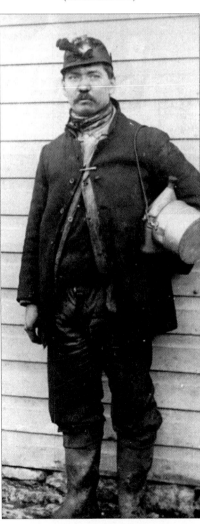

Thomas Shapbell, 1915. (N. June Shapbell)

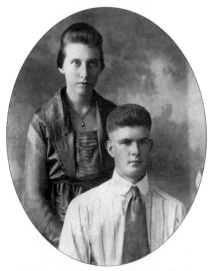

Ethel Blanche Mitchell (née Miller) and Luther Calvin Mitchell, c. 1918. (J. Sweatman)

Unidentified subject, 1919. (Joan M. Hanshew)

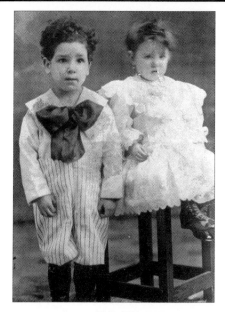

Rose and John Ullo, 1917.
(Mary Jo Sutter)

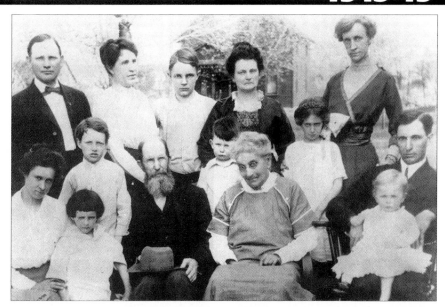

The Spencer family, 1917.
(Chris T. Spencer)

Eleanor McGinley Yoakam, 1916.
(Maureen Bruner)

Amelia I. (Horz) Stolzenbach holding Ruth and
Helen, 1918. (Debbie Hoffman)

Mildred Jenny, Florence, Alice and Charles
White, 1917. (Nan McComber)

George Amador Rohde, 1919.
(Tanya G. Kloesel)

James and Juanita Langdon, 1916.
(Debbie Hoffman)

Clara (Wooster) Merril and George H. Merril,
1917. (A. Gaylord Oberin)

James T. Hughes (in WWI uniform), 1917.
(Elizabeth J. Hughes)

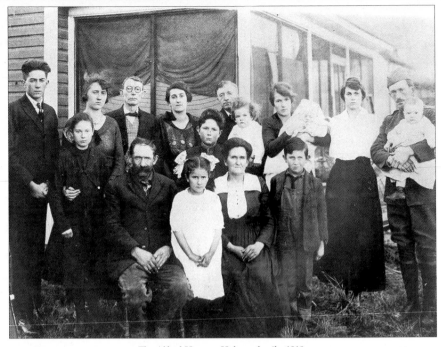

The Alfred Herman Holman family, 1918.
(Laura Lee Holman Welsh)

John E., Juliet and John M. O'Brien, 1915.
(Sara Robertson)

The Braudis children, 1916.
(Jack Braudis)

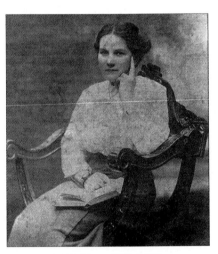

Mildred Jenny White, 1917.
(Nan McComber)

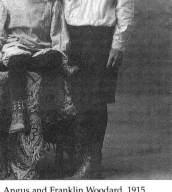

Angus and Franklin Woodard, 1915.
(Shirley Ramsay)

Florence Clancey and children, 1919.
(Janet Foisset)

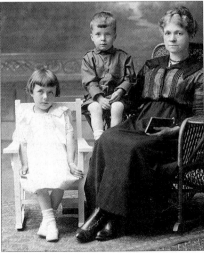

Unidentified subjects, 1918.
(Joseph H. LaMarche)

John Bastille Gandino, Hector and Catherine Marie, 1915. (Anne Crase)

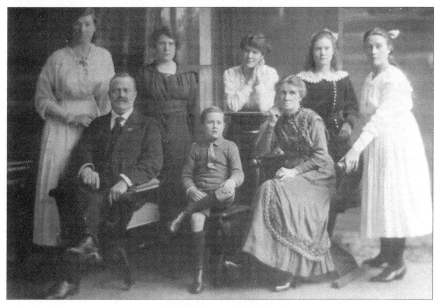

The Hocking family, 1919.
(Elizabeth Crouch)

Howard and Edith (née Weatherbee) Colpitts, 1918. (Donald F. Colpitts)

Percy C. Hughes and James T. Hughes (dressed in WWI uniforms), 1917. (Elizabeth J. Hughes)

William Sanborn Perry, 1918.
(William S. Perry, Jr.)

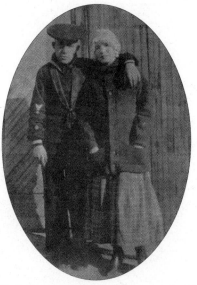

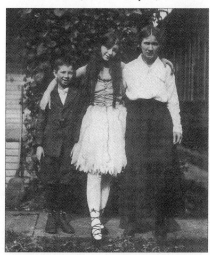

Unidentified subjects, 1919. (Joan M. Hanshew)

Walter and Esther Klingerman, 1916.
(N. June Shapbell)

Sadie Bonewell and Werner Johnson (wearing his WWI U.S. Navy uniform), 1917.
(Nan McComber)

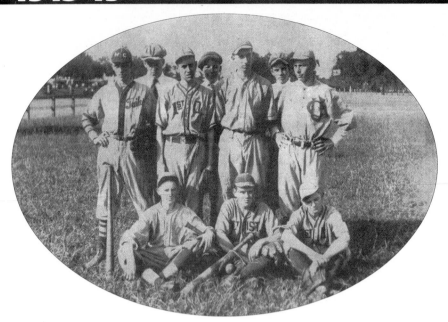

Little Lookouts Baseball Team, Champions in Chattanooga, TN, 1916. (Kay White)

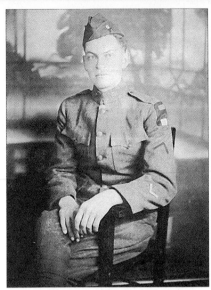

Paul James, Sr., 1918. (Paul J. James)

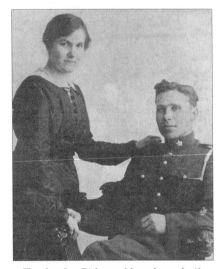

Theodore Jess Dickerson Macomber and wife
Mildred Jenny White, c. 1918. (Nan McComber)

Nellie W. B. Shapbell, 1915. (N. June Shapbell)

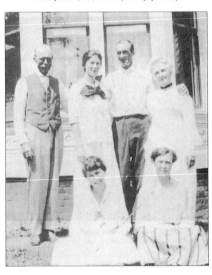

The Murray family, 1918. (William S. Perry, Jr.)

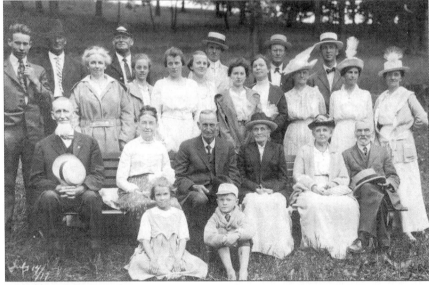

The Horne family, 1917.
(Craig Stevenson)

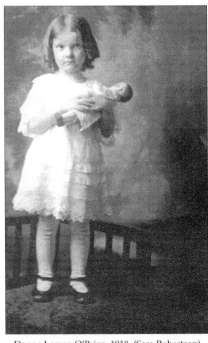

Donna Lemon O'Brien, 1918. (Sara Robertson)

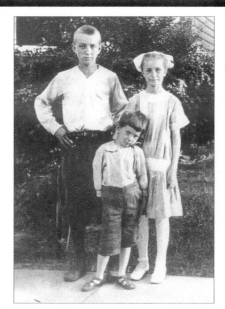
Unidentified subjects, 1915.
(Joan M. Hanshew)

Mildred Yoakam Landon, 1915.
(Maureen Bruner)

Thomas Henry Bonniville and wife Daisy
Belivin, 1917. (Nan McComber)

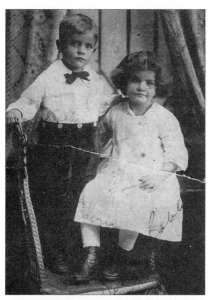
Robert and Susie Butler, 1919.
(Nan McComber)

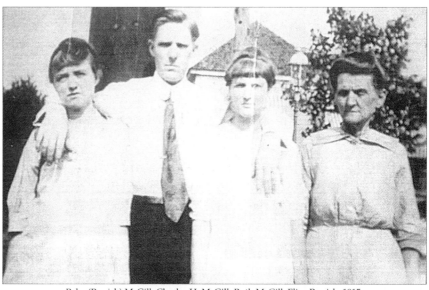
Reba (Parrish) McGill, Charles H. McGill, Ruth McGill, Eliza Parrish, 1915.
(Mary Nell Burnett)

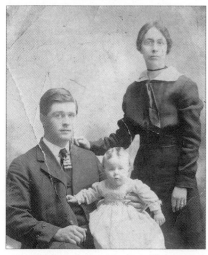
Andrew Brown, Annie Barkely Brown and
daughter Loda May Brown, 1916.
(Ramona Bishop)

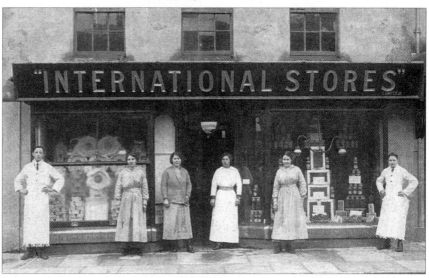
Mildred Jenny White (second from right) and co-workers in Bicester, Oxford, England, c. 1917.
(Nan McComber)

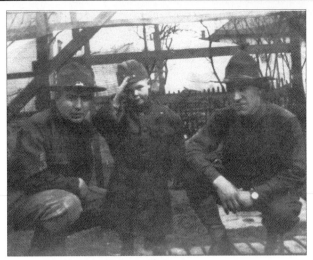

Roy and Chester Pletcher with Billie Kimes (child), 1918.
(Maureen Bruner)

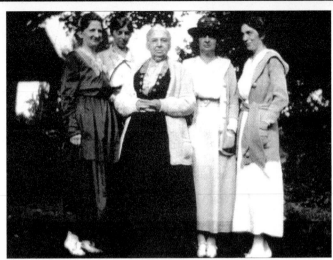

Annie (Wooster) Matthies, Louise Wooster, Anna (Putnam) Wooster, Clara (Wooster) Merril and Mable Wooster, 1917. (A. Gaylord Oberin)

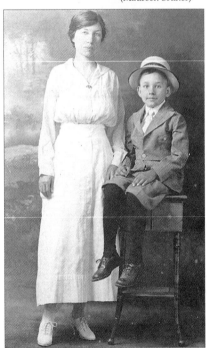

Theodore Willard, Jr. and Mrs. Goff, 1919.
(Betty Jaekle)

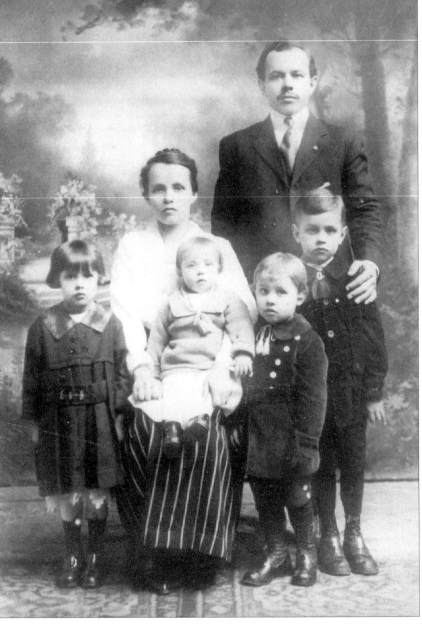

The Bujaki family, 1919.
(Richard Bujaki)

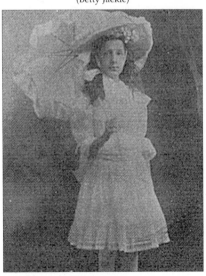

Mary Tomlinson, 1916.
(F. Nelson)

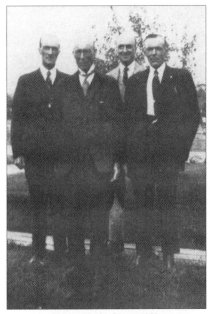

Unidentified subjects, 1922.
(William S. Perry, Jr.)

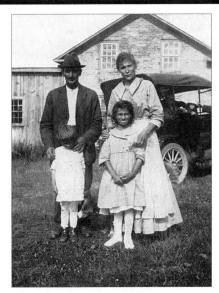

Unidentified subjects, 1920.
(Richard Balge)

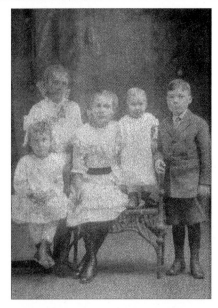

Josephine, Margaret, Edith, John and Frank
Shapbell, 1921. (N. June Shapbell)

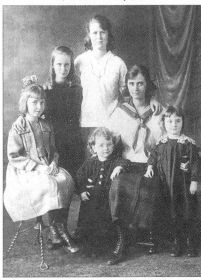

The Belyea sisters, 1920.
(Elizabeth Crouch)

Frederic Russell Robinson, 1920.
(Mary M. Holland)

Mozelle Langdon, c. 1920.
(Debbie Hoffman)

Fiftieth wedding anniversary of Henry Campbell Murray and Margaret A.
Murray, 1922. (William S. Perry, Jr.)

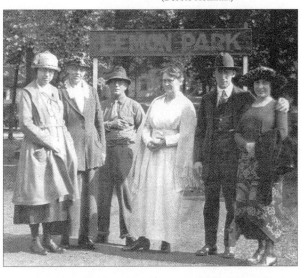

Charles Lemon (third from left), Cora Lemon (right of Charles) and
Susan Klinger Lemon (far right), 1920. (Sara Robertson)

Carrie Lemon (standing), 1920.
(Charles Robertson)

The Warne brothers, 1920.
(Kelly Hokkanen)

Amelie Louise Robinson (Russell), 1920.
(Mary M. Holland)

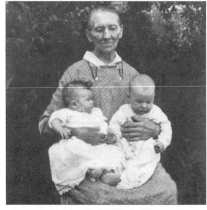

Unidentified subjects, 1923.
(Richard Balge)

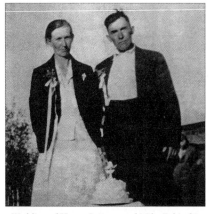

Wedding of Hanna Lytwya and Mike Bobinski,
1923. (Marinus Van Uden)

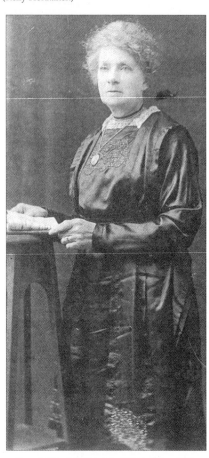

Francis Harriet Trice (née Nankivell), c. 1920.
(Doris Redman)

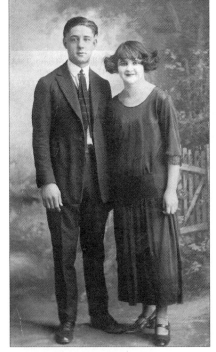

Hector and Catherine Gandino, 1924.
(Anne Crase)

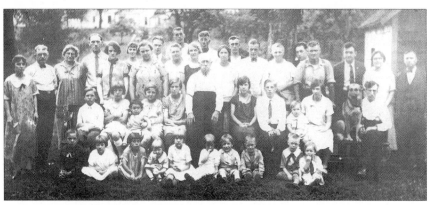

Henry Wilson Cobbett and family, 1924.
(Phyllis Libby Glynn)

The Stephens family, 1920.
(Raymond W. Baalman)

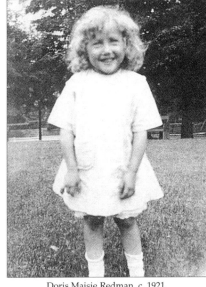

Doris Maisie Redman, c. 1921.
(Doris Redman)

Unidentified subjects, 1923.
(Kat Stubbs)

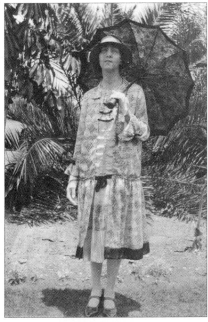

Edith Paterson, 1922.
(Nigel FitzHugh)

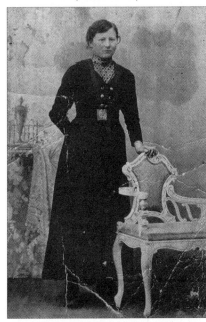

Jacoba Geertruda Hermans, 1920.
(Marinus Van Uden)

The P. Joseph Hess family, c. 1920.
(Debbie Hoffman)

Jim Lawson and sons, c. 1922.
(Jim Lawson)

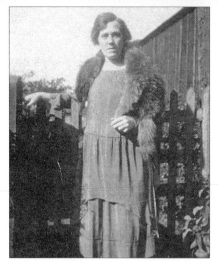

Florence White, c. 1922.
(Nan McComber)

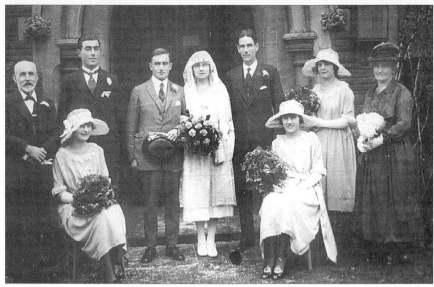

Wedding of Leslie Mark Kerrison and Eleanor Mary Christie, c. 1920.
(Elizabeth Crouch)

Florence Trice, c. 1920.
(Doris Redman)

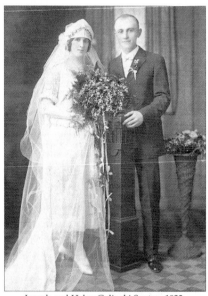

Joseph and Helen Galinski Svatos, 1922.
(Paul Svatos Prium)

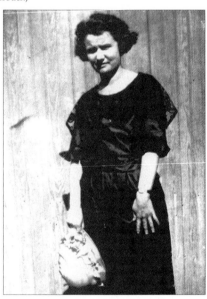

Eleanor McGinley Yoakam, 1923.
(Maureen Bruner)

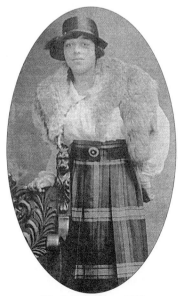

Alberta B. Hughes, c. 1922.
(Elizabeth J. Hughes)

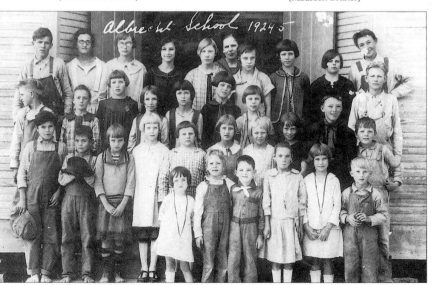

Eula Lee Bertling (top row third from left) at Albrecht School, Gonzales County, TX, c. 1924.
(Karen Monsen)

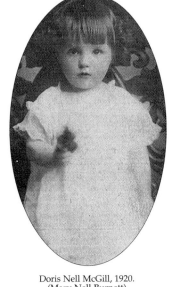

The Reinier Hermans and the Agnes Van Lier family (Holland), 1922.
(Marinus Van Uden)

Doris Nell McGill, 1920.
(Mary Nell Burnett)

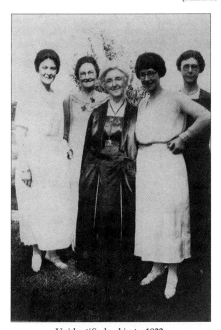

Unidentified subjects, 1922.
(William S. Perry, Jr.)

Mary Newton James, 1922.
(Paul J. James)

Wedding of Mary Ann Hirsch and Leo J. Varsho,
1924. (Lucille Varsho Simpson)

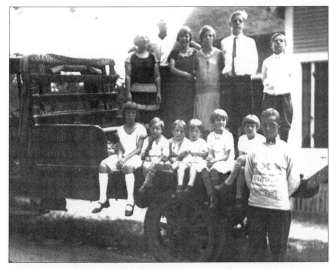

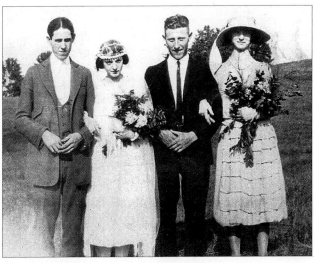

Herbert and Roscoe Libby with Elsena Cobbett Libby and children, 1924.
(Phyllis Libby Glynn)

Unidentified subjects, 1922.
(Joan M. Hanshew)

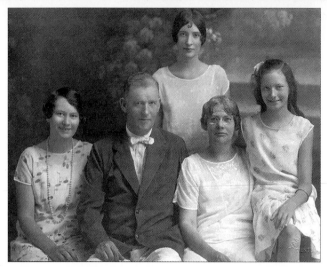

David and May Ritchie with daughters Margaret, Mota and Davona, 1927.
(Mary M. Holland)

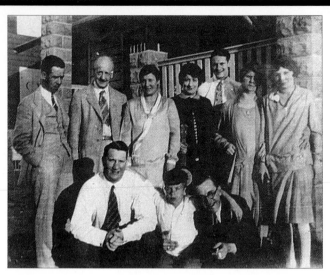

The Green family, 1927.
(Clara Obern)

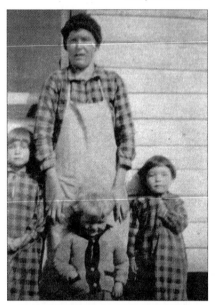

Daisy (née Belvin) Bonniville with children Grace, Evelyn and George Bazil, 1929.
(Nan McComber)

Margaret C. Haran, 1925.
(Peggy Nadolny)

Eva Chapman, Isabelle Chapman and Dorothy Davis Smith, 1927. (Patricia R. Lange)

Rose Ullo and Mary Salvaggio, 1926.
(Mary Jo Sutter)

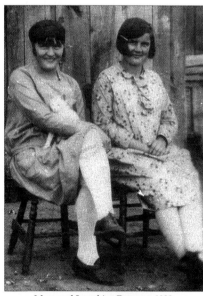

Mary and Josephine Dumont, 1929.
(Shirley Ramsay)

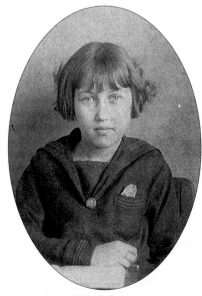

Doris Maisie Redman, c. 1927.
(Doris Redman)

Alice Faye Wernli, 1925.
(Karen Monsen)

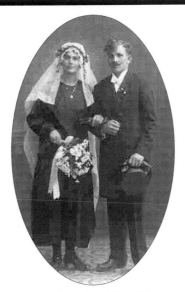

The Gersbach wedding, 1925.
(Marlene Pauly)

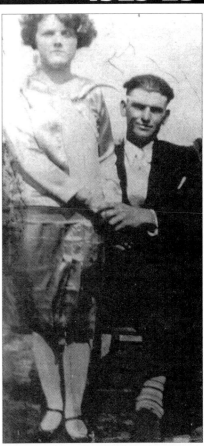

Wedding of Joseph Belvin Jr. and
Mattie Lee Bonniville, 1928.
(Nan McComber)

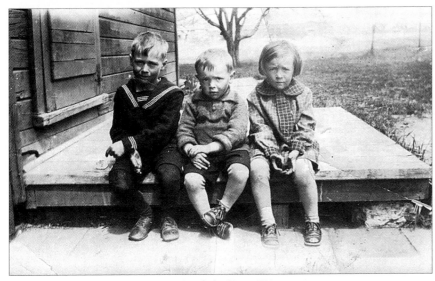

Unidentified subjects, 1928.
(Richard Balge)

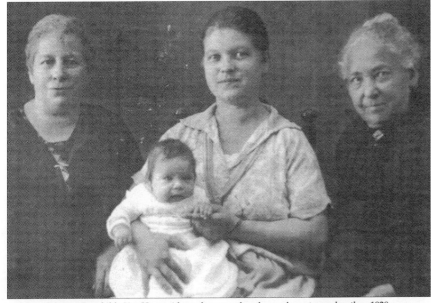

Johanna Brunhilde Van Hout with mother, grandmother and great grandmother, 1928.
(Marinus Van Uden)

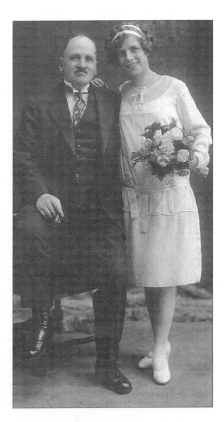

Paul Raddatz Sr. and Lina Raddatz Fischer, 1928.
(Ramona Bishop)

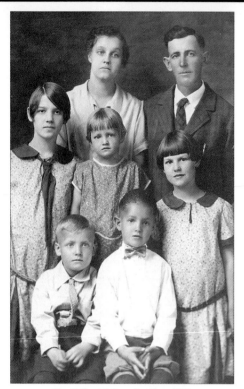

The Delbert Adams family, c. 1927.
(Deborah Hines)

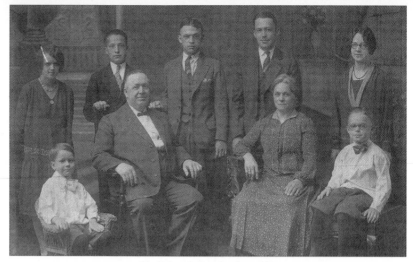

The P. Joseph Hess family c. 1928.
(Debbie Hoffman)

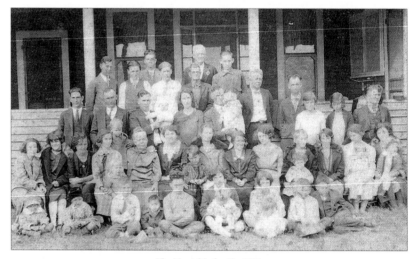

The Huxtable family, 1926.
(Mary Nell Burnett)

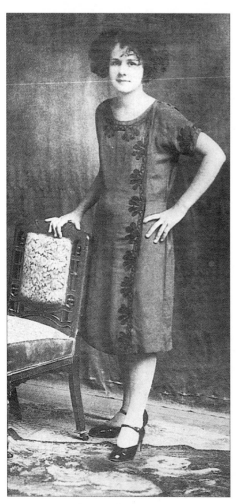

Alice Faye Wernli, 1926.
(Karen Monsen)

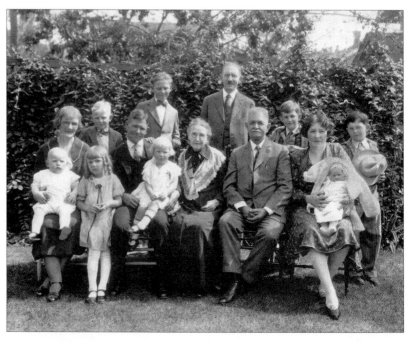

The Frank H. Bradford family, 1926.
(Virginia Bradford)

John Motel, 1928.
(Maureen Bruner)

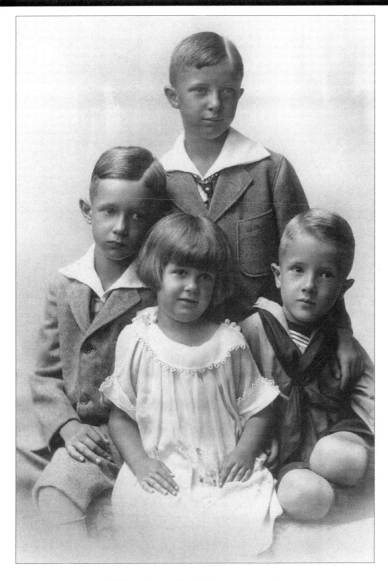

William Wooster Merrill, Jr., Imogene Louise
Merrill, John Henry Merrill and George Herbert Merrill III (standing), 1928.
(Clara Obern)

Donna Lemon O'Brien and Dwight Lemon, 1926.
(Sara Robertson)

Donna Lemon O'Brien, 1928.
(Sara Robertson)

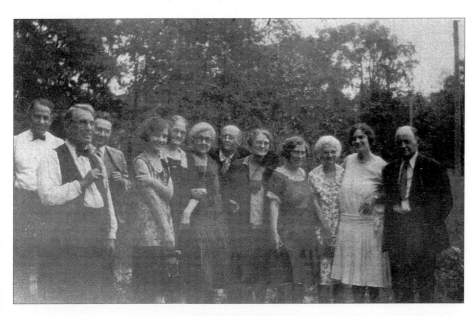

Unidentified subjects, 1929.
(Sara Robertson)

Can't Get Enough of *Family Chronicle?*

Family Chronicle magazine has grown so considerably in circulation and proved so popular, that we reissued almost all the editorial* from the first year of publication in a special edition. In addition to virtually all the articles from the first year, we have added six new articles which we could not find room for in the magazine.

* Articles which the Collection does not include from the first year's issues are: News, Events Calendars, reviews of products no longer available, the Alaska/Yukon Goldrush supplement (which is available on our website). One or two subjects have been covered a second time: in these cases, the later version will be used.

The *Family Chronicle Collection* has been extraordinarily successful and people kept asking when we would follow this up with a reprint of our second year.

Now we can offer readers who missed the issues from September 1997 through August 1998 the complete set. *Family Chronicle Year Two* is not a reprint: we have added the six issues together and bound them into a book with its own cover. You won't miss a word! 336 pages of some of the finest articles on genealogy ever published can be yours.

Family Chronicle's Introduction to Genealogy is a comprehensive guide for the beginner who needs practical advice. The presentation follows *Family Chronicle's* popular format. Features include how to find information about your ancestors in Vital Records, City Directories, Census and other records, Using Family History Centers, Libraries and National Archives, a summary on a dozen European countries. We introduce you to computers, with advice on the type of computer to use, an overview of the software packages available, tips on getting online and making the most out of the Internet. Plus MUCH more!

$25 EACH (US Funds)

$30 EACH (Canadian Funds) Prices include Shipping.

Special Publications from *Family Chronicle*

Call now to order using your credit card

1-888-326-2476

or order through our secure online service: www.familychronicle.com

By mail from the US, send check or money order for $25 (US funds) **each** to:
Family Chronicle
PO Box 1201, Lewiston, NY, 14092.

Canadian orders send cheque or MO for $30* (Cdn funds) **each** to:
Family Chronicle
505 Consumers Road, Suite 500, Toronto, ON, M2J 4V8.
*add GST or HST as applicable. Ontario residents add PST.

Subscribe Now to

How did our ancestors live?

History Magazine is targeted at people who want to know about the lives their ancestors led: what did they eat, how much did they earn, what made them laugh or made them cry?

Here are just some of the articles we have carried in our first six issues: The Atlantic Cable, The Black Death, The National Road, Cleanliness, The 1750s, Bread, The Code Napoleon, The First Radio Station, The Longbow, 1000AD, The US Cavalry, Custer, Army Wives, Death Customs, Bellevue Hospital, The Impact of the Potato, An 1860s Dinner for Eight, The Rifle, The 1820s, The Oregon Trail, The Handcart Pioneers, The Impact of Refrigeration, Games People Played, Contraception, The Suez Canal, Midwives, Longitude, History of the Telephone, The Blacksmith, the 1910s, Early Newspapers, 1918 Influenza Pandemic, Alchemy, Chicago in 1880, The Country Store, Freemasonry, Votes for Women, The Cotton Gin, Lighthouses, Scrapbook for the 1870s, The 1900 House, Let's Eat, Carpetbaggers, Lunatic Asylums, The Natchez Trace, Brandnames, Development of Photography, The Underground Railroad, Scrapbook for the 1690s, California Gold Rush, The Shakers, History of Insurance, Memsahibs of the Raj, Polio, Wigs and many more!

Guarantee

There is no risk. If *History Magazine* fails to meet your needs, or live up to the promises we have made, you are entitled to a refund on all unmailed copies for any reason or no reason. Any refund will be made promptly and cheerfully.

Halvor Moorshead
Editor & Publisher

History
Magazine